The
Desert
Caves
of
Saudi Arabia

John Pint

هيئة المساحة الجيولوجية السعودية
SAUDI GEOLOGICAL SURVEY

الكهوف الصحراوية
في المملكة العربية
السعودية

جون ج بِنْت

الكهوف الصحراويه في المملكه العربيه السعوديه

ستيسي العالمية

The
Desert
Caves
of
Saudi
Arabia

STACEY INTERNATIONAL

The Desert Caves of Saudi Arabia

published by
Stacey International
128 Kensington Church Street, London W8 4BH
Tel: +44 (0) 207 221 7166; Fax:+44 (0) 207 792 9288
E-mail: enquiries@stacey-international.co.uk

ISBN: 1 900988 48 8

British Library Cataloguing-in-Publication Data
A catalogue record for this publication is available from the British Library

Designed by **Kitty Carruthers**

PHOTOGRAPHIC CREDITS

All photographs are by John Pint except those illustrations listed below which are reproduced by kind permission of:

Lars Bjurström cover, i, 2, 7, 17 (bottom), 19, 32, 39-45, 46 (top), 47 (top), 49, 51, 54, 57 (bottom), 70, 74-76, 80, 85, 86, 89 (bottom left and right), 91, 107 (top left), 112 (top), 113 (top), 115 (top), 118; Susana Pint ix, 8 (bottom), 12, 15, 17 (top), 97 (bottom), 99,113 (bottom); Erik Bjurström 5, 28, 56 (bottom), 79; Ralf Benischke 21-27; Tim Barger xii, xiii; Peter R Johnson xv, xvi; Poul 10 (top)

الكهوف الصحراوية في المملكة العربية السعودية

الناشر
ستيسي العالمية

تصميم: كيتي كاروثرز

ACKNOWLEDGEMENTS

It was **Dr Maher Idris** who conceived the idea of a book describing the first caves explored in Saudi Arabia and who paved the way for turning this concept into a reality. In addition, Dr Idris has unstintingly supported the reconnaisance and scientific study of new caves all around the Kingdom of Saudi Arabia. In the name of everyone listed below: *shukran jazilan,* Dr Idris!

The photographs in this book were taken, often under very difficult circumstances, by Lars Bjurström, Susana Pint, Erik Bjurström, Poul, Ralf Benischke, Tim Barger and myself.

Many thanks to the editors of the Arabic text, Dr Hussain M Sabir and Osama A Al-Sebaei.

Of course, there would be no beautiful pictures of Saudi caves without the efforts of the explorers who risked their lives rappelling into deep holes or crawling through tight passages in the pursuit of an extraordinary beauty and excitement that is only found deep underground. One of these persons was my wife, Susy Pint, who fell in love with caves in this fascinating country. In addition, particular recognition must be given to the individuals below.

John J Pint

Saudi Geological Survey Cave Unit

محمود الشنطي Mahmoud Alshanti
سعيد العمودي Saeed Al-Amoudi
عبد الرحمن الجعيد Abdulrahman Al-Juaid

Other past and present explorers of Saudi Arabian caves

Ammar Abdulshakoor
Rami Akbar
Abdullah Al Eisa
Husam Al Madkhali
Addulaziz Al-Aghili
Mohammed Al-Kaff
Adly K Al-Saafin
Saad S Al-Sayari
Ghassan Al-Sulaimani
Faisal Allam
Mohammed Asaigh
Chuck Ault
Sam Ayoub
Kamal Babour
Talat A Bader
Ahmed Banakhar
Tom Barger
Ralph Benischke
Frank Binney
Erik Bjurström
Lars Bjurström
Dave Black
Jean-Louis Bourgeois
Dave and Carol Canning

Mike Chester
Andrea Chow
Paul Courbon
John Crider
Abdullah E Dabbagh
Martin Danks
Phil Darby
Bruce and Anna Davis
Henri De St Pierre
Christophe Delestre
Kevin Devlin
William S Dirks
H S Edgell
Hesham Elabd
Faraj of Shawiyah
Dominik Fleitman
Arlene Foss
Gerald Fuchs
Mike Gibson
Steve Glover
Greg Gregory
Jonathan Grosch
Mohammed Halawani
Odette Harmsen

Peter Harrigan
Lee Hoang
Linda Holloway
Adele Hollowes
Heinz Hötzl
Katherine Hurley
Oguz Irtem
Abdul Raof Jado
John and Margaret Jenkins
D H Johhnson
Larry Johnson
Waddia Kashkari
Mohammed Kassem
Chris Killey
Wil Kochinski
Norbert Kremla
Ron Kummerfeld
Marc Lamontagne
Dan Leonik
Karl Leyrer
Bob and Judy MacDonnell
Bertrand Masson
Albert Matter
John McLeod

Philippe Montaggioni
Dany Mounsef
Roy Mueller
Paul and Lou-Anne Nicholson
Larry Norton
Tess Oneill
Dave Peters
Lennart Richt
John Roobol
Lise Roussel
John Semple
William Shehata
Tom Southworth
M Steineke
Andy and Ionis Thompson
Jonathan G Tomkins
Fabrice Uran
Peter Wade
Volker Weissensteiner
Katie West
Stefan Wohnlich
Josef Zötl

CONTENTS المحتويات

INTRODUCTION

The earliest explorers of Saudi Arabia's desert caves were bedouins, whose daily lives represented a never-ending struggle for survival in one of the harshest environments on earth. For them, the caves promised a possible respite from heat, cold and howling sandstorms. Many times, a brackish pool hidden at the bottom of a deep pit was their only source of water.

Modern cave explorers crawl into dark voids beneath the sands for other reasons. Some are attracted by the strange and often breathtaking environment, totally unlike the stark desert above. Others are taken by the sheer challenge of risking life and limb on a thin nylon rope to penetrate an inky-black world where one small mistake can result in death. All of these explorers relish the possibility of reaching large caverns where no human being has been before.

For the most part, the photographs in this book represent cave exploration in Saudi Arabia during the last twenty years. This activity was triggered by a study of old maps showing a great number of natural water wells clustered around a small settlement named Ma'aqala, located just east of the Dahna desert atop a great bed of limestone and dolomite known as the Umm-Er-Radhuma formation. Cavers requested permission to explore these cavities from the Emir of Ma'aqala who assigned a knowledgeable old-timer to guide the visitors to the caves. He led them to a hard-pan area filled with holes, within walking distance of the red sand dunes of the Dahna. These cavities they explored methodically, frequently finding all the horizontal passages blocked by sand, with no sign of the limestone formations they had hoped to see.

The situation seemed less than encouraging until the day they came upon a small hole no wider than a dinner plate. Warm, humid air was blowing from this hole so strongly that it seemed worth the effort to enlarge it with a chisel.

When the opening was finally big enough to admit a human visitor, the cavers squeezed into the hole, their unseen feet feeling for each rung of the cable ladder swinging to and fro in the darkness. They descended into a bell-shaped room which led them to a labyrinth of horizontal passages. Here they found stalactites, stalagmites, columns and other calcite and gypsum formations of great beauty and variety. Every time they thought they had reached the end of the cave, which they named

Dahl Sultan, they found new passages leading in unexpected directions. They realized that Saudi Arabia has limestone caves of great size, beauty and complexity and their enthusiasm knew no bounds.

As more and more remarkable caves were located, word reached the scientific community, inspiring geologists, biologists and hydrologists to investigate. Following these early explorations, the first author joined the Saudi Geological Survey (SGS) and an SGS subproject was established to explore and examine the caves in the Umm-Er-Radhuma and elsewhere in a systematic manner. No matter what remains to be discovered, however, the early cavers will not forget the wonderful sights that met them when they first succeeded in entering Dahl Sultan, and this book, in part, commemorates their achievement. For more pictures and details about the Saudi caves you can visit www.saudicaves.com.

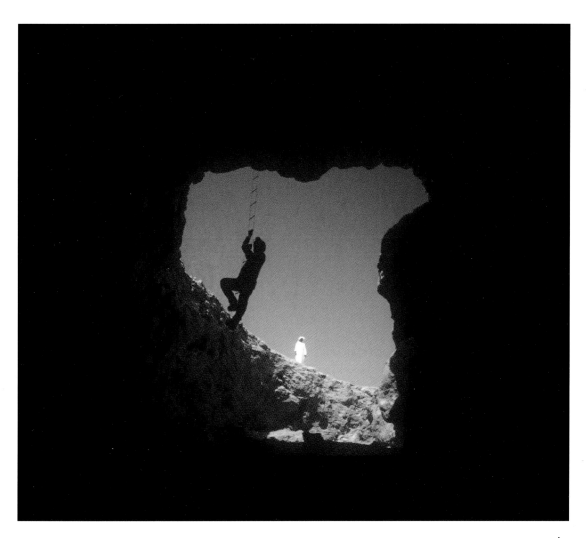

ورسم خرائط العديد من كهوف الحجر الجيري في الجزء الشمالي من المملكة. كما بدأ العمل في استكشاف كهوف أنابيب اللابة (حمم البراكين) في الجزء الغربي من المملكة. وسوف تظهر نتائج هذه الدراسات من خلال المجلدين الثاني والثالث ضمن هذه المجموعة. وبغض النظر عن ما سيتم إكتشافه، فإن مستكشفي الكهوف الأوائل لن ينسوا تلك المشاهد الرائعة التي صافحت أعينهم عندما نجحوا في الدخول الى دحل سلطان لأول مرة.

للحصول على أحدث التقارير والصور عن الكهوف السعودية يمكنكم زيارة الموقع:

www.saudicaves.com

المقدمة

يعود استكشاف الكهوف الصحراوية في المملكة العربية السعودية إلى السكان المحليين وذلك بحكم تنقلاتهم المستمرة في الأراضي الصحراوية الشاسعة. وبالنسبة لهم فان الكهوف تعتبر ملاذاً آمناً يقيهم الحر والبرد والعواصف الرملية. وفي كثير من الأحيان كان وجود بركة ماء ضارب إلى الملوحة مخبأة في قاع حفرة عميقة يعتبر المصدر الوحيد للماء.

يدخل مستكشفو الكهوف في يومنا الحالي الى أعماق الفجوات المظلمة المدفونة تحت الرمال لاسباب عدة، فبعضهم تجذبه البيئة الغريبة والخلابة أحياناً التي تتباين تماماً مع الصحراء العارية فوق السطح ، وبعضهم يتوق للتحدي بالمخاطرة بحياته المعلقة بحبل نايلون رفيع يدخل بواسطته الى عالم مظلم مجهول حيث يمكن أن يؤدي خطأٌ بسيطٌ الى الموت. ويسعى جميع هؤلاء المستكشفين للوصول الى مغارات كبيرة لم يسبقهم اليها اي انسان من قبل.

تمثل الصور التي يحتوي عليها هذا الكتاب في غالبيتها استكشاف الكهوف في المملكة العربية السعودية خلال الفترة من عام ١٩٨٠م الى عام ٢٠٠٠م. وقد بدأ هذا النشاط بدراسة خرائط قديمة توضح عدداً كبيراً من آبار المياه الطبيعية المتجمعة حول قرية صغيرة اسمها "المعاقلة" تقع شرق صحراء الدهناء على قمة طبقة واسعة من الحجر الجيري و الدولوميت معروفة باسم متكون "أم رضمة". وقد حصل المستكشفون على اذن من الجهات المختصة للقيام بدراسة تلك الفجوات وعين لهم دليل ليصحبهم أثناء زيارتهم لها. وقادهم الدليل الى منطقة ذات طبقة ترابية صلدة تحتوي على الكثير من الحفر ولا تبعد كثيراً عن كثبان الرمال الحمراء لصحراء الدهناء. وتم استكشاف تلك الفجوات بصورة منتظمة. وكانت جميع الممرات الافقية مسدودة بالرمل مع عدم وجود اية علامة لوجود متكونات الحجر الرملي التي كانوا يأملون مشاهدتها.

وكان الوضع غير مشجع حتى ذلك اليوم الذي وصلوا فيه الى حفرة صغيرة لا يزيد عرضها عن حجم طبق طعام، وكان الهواء الدافئ الرطب يهب من تلك الحفرة بقوة مما شجع على توسعتها باستخدام ازميل. و عندما اكتملت توسعة الحفرة بحيث تسمح بدخول انسان اليها بدأ المستكشفون النزول داخلها باستخدام السلالم المعدنية، وهبطوا داخل غرفة على شكل جرس مخروطي وبعدها الى شبكة من الممرات الأفقية. وهنا وجدوا مجموعات من الهوابط والصواعد والاعمدة ومتكونات أخرى متنوعة من الكالسيت والجبس ذات جمال باهر. وكلما ظنوا أنهم وصلوا إلى نهاية الكهف وجدوا ممرات جديدة تقودهم الى اتجاهات غير متوقعة، واطلقوا على الكهف اسم "دحل سلطان". وهنا ادركوا ان المملكة العربية السعودية تحتوي على كهوف من الحجر الرملي ذات أحجام وجمال وتعقيد كبير. وزادت تلك الحقيقة من حماسهم العلمي محفزة الجيولوجيين وعلماء الأحياء والمياه للقيام بدراسة تلك الكهوف.

وفي أعقاب هذه الاستكشافات الاولى، تبنت هيئة المساحة الجيولوجية السعودية هذه الجهود والتحق المؤلف الأول بها، حيث تم اعداد مشروع فرعي لاستكشاف ودراسة كهوف متكون أم الرضمة والكهوف الأخرى بطريقة منتظمة. ومع ارسال هذا الكتاب الى المطبعة يتم دراسة

DAHLS AND SURVIVAL IN THE DESERT

Writing of his visit to the northern Summan plateau in 1917-18, Philby describes natural shafts or dahls (*duhul* in Arabic) up to ten metres deep, where rain water tended to collect in pools. Aramco CEO Tom Barger, writing from Ma'aqala in 1939, reported:

> "The water comes from dahls, sinkholes in the limestone that vary from a foot to 10 feet in diameter. The one with the most water has the dirtiest water; it is more thin mud than water. The biggest one requires crawling through 100 yards of winding tunnel and dragging the water out in *gurbas* [water-skins]."
> (*Out in the Blue*, Selwa Press, 2001)

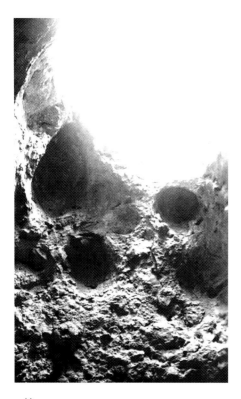

Entrance to a dahl seen from the bottom. Before venturing into the darkness of a subterranean maze, a bedouin would tie a rope around his waist to avoid losing his way.

مدخل دحل كما يشاهد من الأسفل. وقبل المغامرة بالنزول إلى مجهول تحت سطحي يقوم المستكشف بربط حبل حول خاصرته حتى لا يضل طريقه.

الدحول والنجاة من الصحراء

وصف فيلبي خلال زيارته الى هضبة الصمان الشمالية في عامي ١٩١٧م و ١٩١٨م المهاوي الطبيعية او الدحول التي يصل عمقها إلى عشرة أمتار حيث تتجمع مياه الأمطار في بحيرات. ووصف المشهد توم بارجر المدير التنفيذي لشركة أرامكو خلال وجوده في المعاقلة في عام ١٩٣٩م بالقول:

"تأتي المياه من الدحول وهي عبارة عن بالوعات داخل الحجر الرملي تتراوح أقطارها ما بين قدم واحد الى عشرة أقدام. والدحل الذي يحتوي على أكبر كمية من المياه تكون المياه بداخله الأكثر قذارة فهو أقرب أن يكون طيناً سائلاً من كونه ماءً، ويحتاج أكبر الدحول للزحف لمسافة ١٠٠ ياردة من الانفاق المتعرجة لاستخراج الماء داخل أوعية مصنوعة من الجلد (القِرَب)."

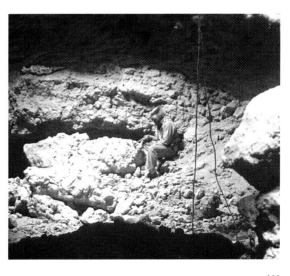

Some dahls also provided escape from the heat. Barger and friends would take cots into a big dahl near Ma'aqala (perhaps Murubbeh) and sleep "in the cool, natural air conditioning of the cave."

توفر بعض الدحول ملاذاً من الحر. يأخذ بارجر وأصدقاؤه مفارش داخل دحل كبير بالقرب من المعاقلة (ربما كان دحل المربع) وينامون في الهواء البارد المكيف طبيعياً داخل الكهف.

GEOLOGY OF THE CAVES OF CENTRAL SAUDI ARABIA

Peter R Johnson

Introduction

This book is a collection of photographs of a group of underground caves around the town of Ma'aqala 200-250 km north-northeast of Ar Riyadh, in a region that is quite flat, 400-450 m above sea level. The caves are now located in the desert, but were formed by the action of rain and running water.

What are Caves?

Caves are airfilled underground voids developed by the former action of water on rock that over a long period of time was dissolved, opening up holes and tunnels in the ground. The holes and tunnels in cave systems are normally interconnected, depending on how the water seeped through the rock along joints and cracks, working its way down to the water table below the surface of the ground.

The caves illustrated here are in limestone – the most common type of rock to have caves – which in this part of Saudi Arabia consists of calcium carbonate and small amounts of magnesium carbonate. The rocks formed 50 million years ago from the calcareous shells and skeletons of countless organisms that flourished in shallow warm seas that covered the Arabian Peninsula. Over time, the shelly deposits were cemented by additional calcium carbonate, became hard and turned into limestone, forming a geologic unit referred to as the Umm er Radhuma and Rus Formations (see map). Starting 25 million years ago, these formations were raised above sea level by earth movements affecting the whole of the Middle East, and were exposed to wind and rain at the surface.

The action of water percolating down through soluble rock is critical for the formation of most caves. Some caves develop because sulphuric acid rises from deep below the surface, but this is rare and it is not known if any of the caves in this book formed in this fashion. Most likely they all formed by water action – either by falling rain or by streams that sink into the ground through joints and holes.

The process of forming caves in soluble rock is very slow. As rain falls through the air, it absorbs a small amount of carbon dioxide and picks up

جيولوجية كهوف المنطقة الوسطى
في المملكة العربية السعودية

إعداد: بيتر آر جونسون

المقدمة

يضم هذا الكتاب مجموعة مختارة من الصور الفوتوغرافية لمجموعة كهوف جوفية حول قرية المعاقلة الواقعة على بعد ٢٠٠ الى ٢٥٠ كيلو متراً شمال شمال شرق مدينة الرياض في منطقة منبسطة تقع على إرتفاع ٤٠٠ الى ٤٥٠ متراً فوق سطح البحر. وتقع الكهوف حالياً في الصحراء وقد تكونت بفعل الامطار والمياه الجارية.

ماهي الكهوف؟

تمثل الكهوف فوهات جوفية مملوءة بالهواء نشأت بفعل حركة المياه سابقاً على الصخور مما أدى الى إذابة الصخور على مدى فترة زمنية طويلة وتكوين فتحات وأنفاق داخل الارض. والفتحات والانفاق الموجودة في نظم الكهوف غالباً ما تكون متصلة ببعضها تبعاً لكيفية تسرب المياه عبر الصخور على طول الفوالق والشقوق وصولاً الى منسوب الماء الباطني تحت سطح الأرض.

تقع الكهوف المصورة في هذا الكتاب داخل الحجر الجيري (أكثر أنواع الصخور شيوعاً باحتوائه على الكهوف) والذي يتكون في هذا الجزء من المملكة العربية السعودية من كربونات الكالسيوم

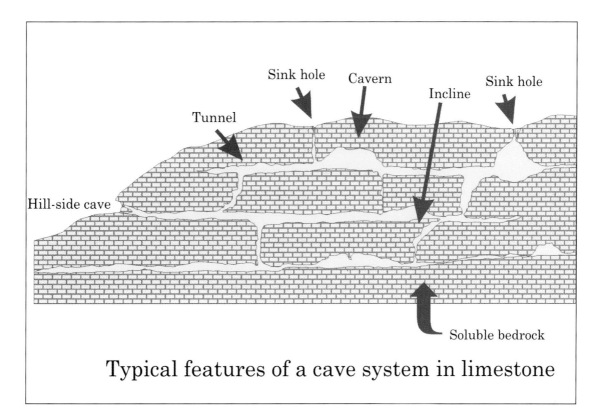

Typical features of a cave system in limestone

additional carbon dioxide from the soil. The result is a weak solution of carbonic acid that seeps downward, dissolving the limestone bedrock and opening up cavities and interconnected channels. If streams flow on the surface – and in the recent geologic past, Saudi Arabia was much wetter and probably had permanent drainage – additional weakly acid water would enter the limestone where streams sink down holes and cavities. The underground water will move along the bedding and down the joints, forming long tunnels by combined solution and normal erosion. Sometimes the water moves very slowly and dissolves the rock instead of wearing it away, creating an intricate labyrinth of passageways. In other places, joints become enlarged resulting in vertical shafts and chimneys.

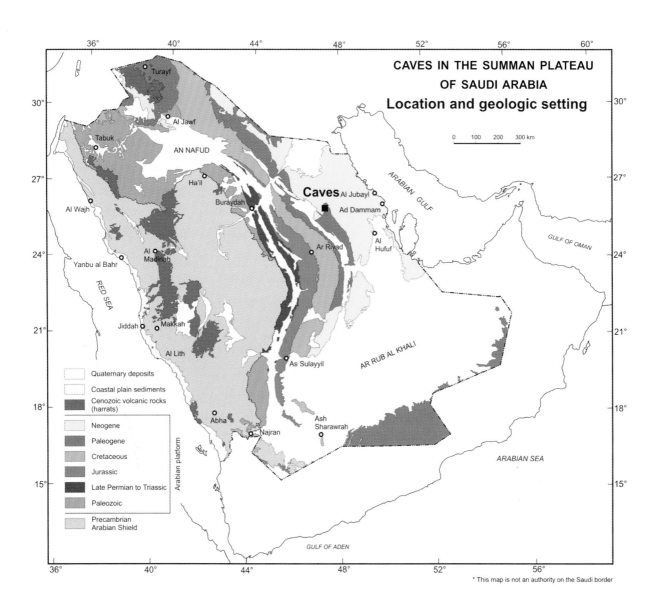

وكميات صغيرة من كربونات المغنيسيوم. وقد تكونت الصخور قبل ٥٠ مليون سنة من الاصداف الجيرية والهياكل العظمية لأحياء لا حصر لها كانت تعيش في البحار الدافئة الضحلة التي كانت تغطي شبة الجزيرة العربية. وبمرور الوقت تلاصقت الرواسب الصدفية بمزيد من كربونات الكالسيوم وأصبحت صلدة وتحولت الى حجر جيري مكونة وحدة جيولوجية تعرف باسم متكوني أم الرضمة والرس. وابتداءً من ٢٥ مليون سنة خلت تم رفع هذين المتكونين فوق سطح البحر نتيجة للحركات الارضية التي أثرت على كامل منطقة الشرق الأوسط وانكشفت وأصبحت تحت تأثير الرياح والامطار على السطح.

يعتبر تأثير المياه التي تتسرب للاسفل عبر الصخور المذابة ضرورياً لتكوين معظم الكهوف. وتنشأ بعض الكهوف لأن حامض الكبريتيك يرتفع من الاعماق تحت السطح وهذه ظاهرة نادرة. ولم يتضح اذا كان اي من الكهوف الوارد وصفها في هذا الكتاب قد تكونت بهذه الطريقة. وعلى الارجح انها تكونت جميعاً بفعل حركة الماء إما بواسطة هطول الامطار او بالانهار التي تتسرب داخل الارض عبر الفوالق والفتحات.

إن عملية تكوين الكهوف في الصخور المذابة بطيئة للغاية. ومع هطول الامطار عبر الهواء تمتص مقادير بسيطة من ثاني أكسيد الكربون ثم تحصل على المزيد من ثاني أكسيد الكربون من التربة. ونتيجة لذلك يتكون محلول خفيف من الحامض الكربوني الذي يتسرب للاسفل ويذيب صخر القاعدة المكون من الحجر الجيري مما يؤدي لفتح التجاويف والقنوات المتصلة مع بعضها. واذا كانت الانهار تسيل على السطح (وفي الماضي الجيولوجي القريب كانت المملكة العربية السعودية تتمتع بمناخ أكثر رطوبة ويحتمل أنها كانت تحتوي على مصارف مياه دائمة) فإن المزيد من الماء الحامض الخفيف سوف يدخل إلى الحجر الجيري عند مواقع تسرب الانهار للاسفل عبر الفتحات والتجاويف. وتتحرك المياه الجوفية على طول التطبق وللاسفل عبر الفوالق مشكلة قنوات طويلة بواسطة الإذابة والتعرية العادية، وفي بعض الاحيان يتحرك الماء ببطء شديد ويذيب الصخر بدلاً من تآكله ويشكل ذلك سرداباً متشابكاً من الممرات. وفي اماكن اخرى تصبح الفوالق متضخمة وينتج عن ذلك تكوين أنفاق وفتحات رأسية.

الرواسب الكهفية

إن جزءاً كبيراً من الاعجاب الذي يبديه الناس للكهوف يعود للأنواع المتباينة الرائعة من الرواسب التي تتشكل داخل الكهوف بعد انخفاض مستوى سطح الماء الباطني وجفاف تلك الكهوف. وذلك لأن الماء الذي يسيل داخل الكهف المملوء بالهواء حالياً لايزال محملاً بالمعادن المذابة التي تترسب تبعاً لهروب ثاني أكسيد الكربون من الماء. ونتيجة لذلك تتكون الرواسب الكهفية (ترسبات من كربونات الكالسيوم). ويوجد نوعان رئيسيان من هذه الرواسب: الهوابط التي تكونت بفعل سقوط المياه من السقف وتكون متدلية على شكل مخاريط من سقف الكهف، والصواعد التي ترتفع من أرضية الكهف بفعل تساقط قطرات الماء فوق بعضها البعض. وتحتوي بعض الكهوف على طبقات جميلة من المعادن نتيجة لجريان طبقات خفيفة من الماء على جدران الكهف أو على طول المنحدرات ، بينما تحتوي بعضها على رواسب صغيرة تشبه الحصى أو لآلئ الكهوف التي تنمو داخل برك صغيرة.

Cave Deposits

A large part of the fascination that people feel for caves is because of the wonderful varied types of deposits that form inside caves after the water table drops and they begin to dry out. This is because the water that drips into, or flows through the now air-filled cave, is still full of dissolved minerals that precipitate as the carbon dioxide escapes from the water. The results are cave deposits, or speleothems, as they are technically called. There are two main types: stalactites, which are formed by water dripping from the ceiling and hang from the cave roof and stalagmites, which grow up from the floor where the drops fall. Some caves have beautiful coatings of minerals where thin sheets of water flow down the cave walls or along inclines. Others have small pebble-like deposits or cave pearls that grow in small pools.

The Importance of Caves

Caves are important, not only because they are beautiful and awe-inspiring, but because they provide a detailed record of past climate, surface processes, fauna, and flora.

Careful chemical analysis of the cave deposits reveals information about the abundances of different isotopes of carbon, sulphur, and other trace elements that were present in the atmosphere when the deposits formed and gives an age of the deposits. The two types of information – chemical and chronologic – provide a record of climate change.

Examination of bones, pollen, and spores that may be trapped in dust and silt in the caves, gives information about the types of animals and plants that existed in the recent past in areas that are now desert.

Surveying the caves and mapping the types and distributions of cave deposits provides information about the rise and fall of the water table, which, in turn, is a key to understanding the changing rates of discharge and recharge of the water volume and increases and decreases of rainfall.

أهمية الكهوف:

لا تقتصر أهمية الكهوف على القيم الجمالية فقط بل إنها تعتبر سجلاً تفصيلياً عن المناخ والعمليات السطحية وأنواع الحيوانات والنباتات التي كانت تعيش في الماضي. فالتحليل الكيميائي الدقيق للرواسب الكهفية يكشف معلومات حول تواجد نظائر مختلفة من الكربون والكبريت وآثار بعض العناصر (الاخرى التي كانت موجودة في الغلاف الجوي عندما تكونت الرواسب) وتسمح بتحديد عمر تلك الرواسب. كما أن المعلومات الكيميائية والزمنية تعطي سجلاً تاريخياً للتغييرات المناخية.

وتوفر دراسة العظام وحبوب اللقاح والأبواغ التي تكون عالقة في الغبار والغرين داخل الكهوف، معلومات حول أنواع الحيوانات والنباتات التي كانت سائدة في الماضي القريب في مناطق أصبحت حالياً صحراء. إن القيام بمسح الكهوف ورسم خرائط أنواع وتوزيع الرواسب الكهفية يوفر معلومات حول إرتفاع وهبوط مستوى الماء الجوفي والذي يعتبر بدوره مفتاحاً لفهم المعدلات المتغيرة لتصريف وتغذية المخزون المائي وزيادة ونقصان معدلات هطول الأمطار.

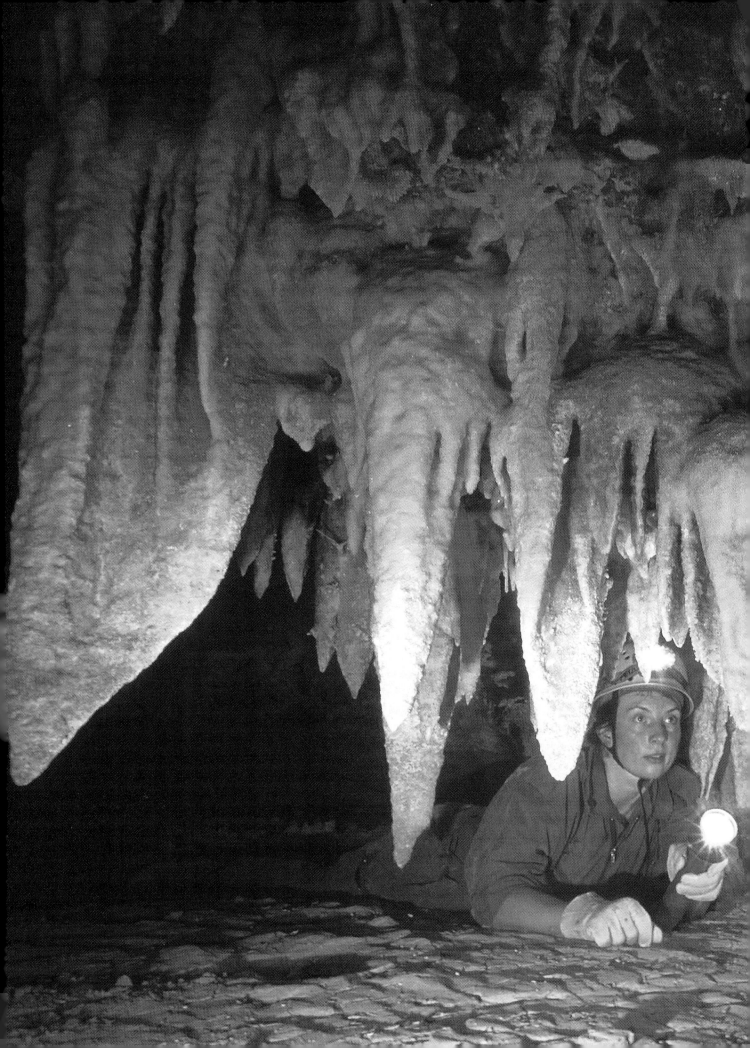

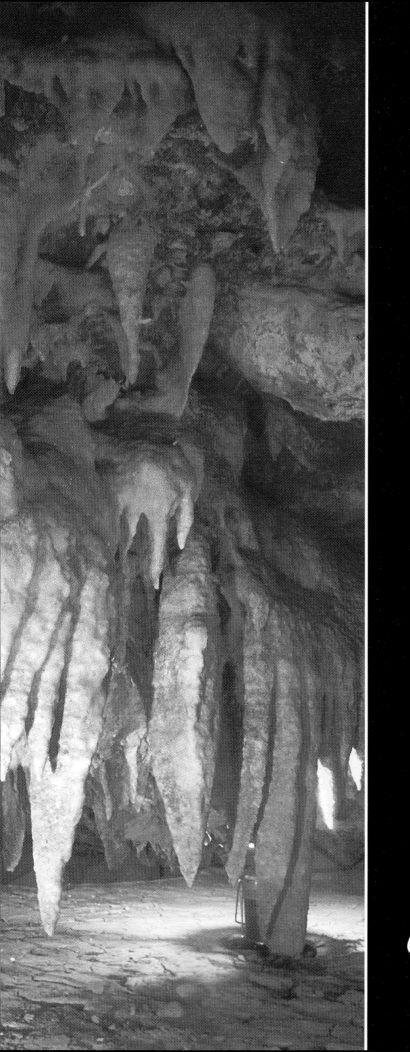

The Discovery of Dahl Sultan

إكتشاف

دحل سلطان

In the early 1980s, cave explorers learned that a large number of pits or dahls were concentrated around a small settlement called Ma'aqala, located alongside the Dahna Desert and with the help of the Emir of Ma'aqala, a study of the area was begun. Many of the cave passages were found to be blocked by drifting sand, but then a small hole was discovered from which a strong current of warm, moist air was blowing. The exploration of what may be the largest cave in Saudi Arabia was about to begin.

في أوائل الثمانينات الميلادية علم عدد من مستكشفي الكهوف أن أعداداً كبيرة من الدحول (الكهوف) تتركز حول قرية صغيرة تسمى المعاقلة تقع بمحاذاة صحراء الدهناء. وبالتعاون مع السلطات المحلية، بدأ العمل في دراسة المنطقة حيث وجد المستكشفون أن العديد من الممرات الكهفية مسدودة بالرمال المتحركة، ولكنهم عثروا على حفرة صغيرة يهب من داخلها تيار قوي من الهواء الدافئ الرطب. إن إستكشاف ما قد يعد أكبر الكهوف في المملكة العربية السعودية على وشك أن يبدأ.

Previous page: a low crawlway will sometimes lead to spectacular formations hundreds of thousand of years old.

Opposite: the water line on these stalactites shows that much of Dahl Sultan was once flooded.

الصفحة السابقة: تؤدي ممرات الزحف المنخفضة أحياناً إلى متكونات مذهلة يعود عمرها لمئات آلاف السنين.

الصفحة المقابلة: يدل خط الماء على هذه الهوابط أن جزءاً كبيراً من دحل سلطان كان مغموراً بالماء في الماضي.

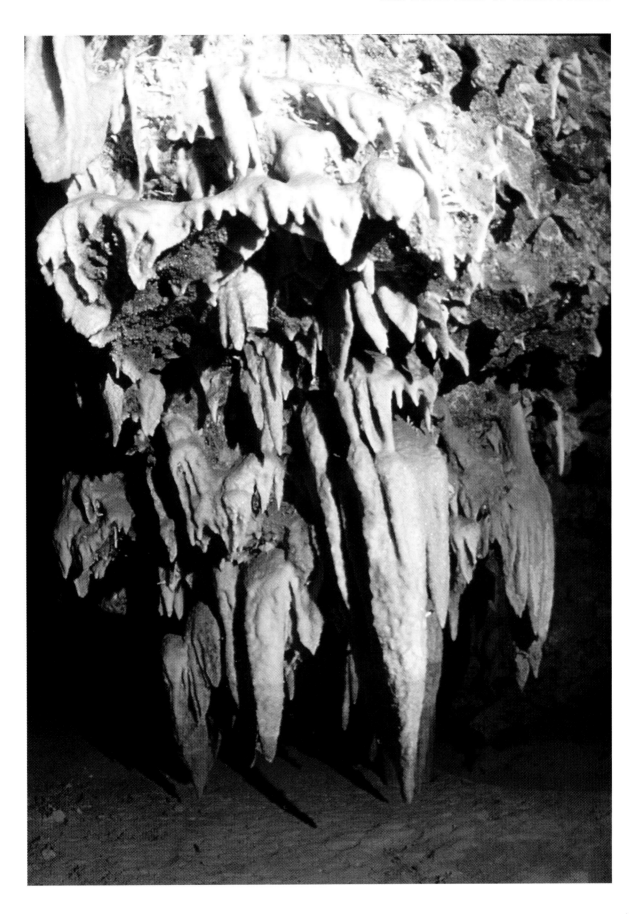

In many parts of Dahl Sultan, visitors can stroll through spacious passageways like this one.

في العديد من أجزاء دحل سلطان يتمكن الزوار من التنقل عبر ممرات فسيحة مثل هذا الممر.

6

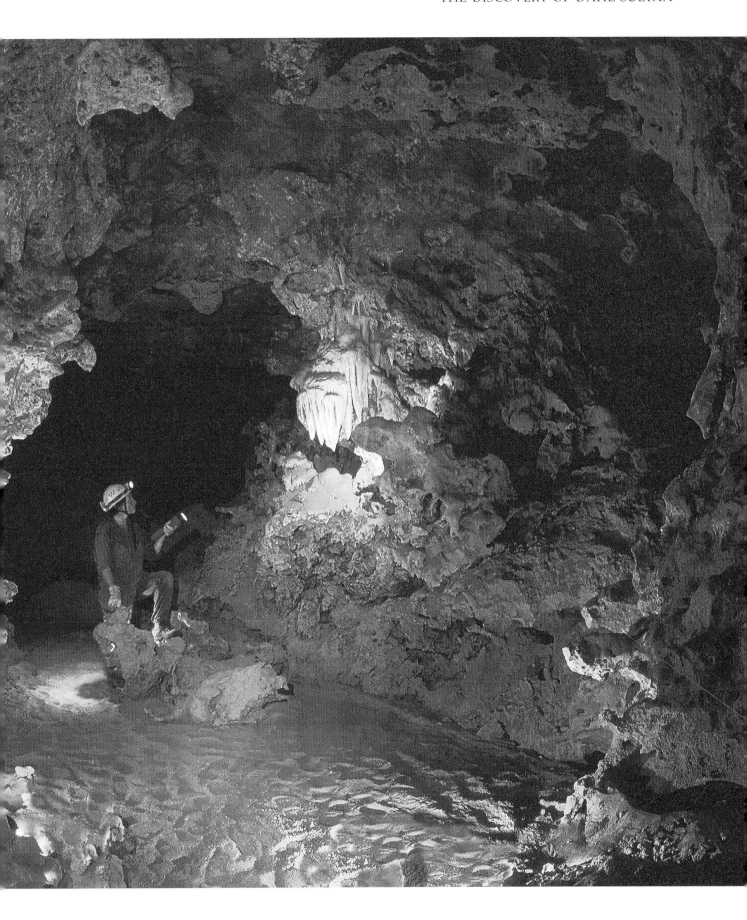

With the help of a chisel, the entrance to Dahl Sultan was enlarged just enough for a thin person to squeeze through.

توسعة مدخل دحل سلطان باستخدام إزميل بحيث أتاح لشخص نحيف فقط المرور عبر الفتحة.

Right: this cave has many unusual, hollow formations which resemble birds' nests.

Below: before the discovery of Dahl Sultan, there was no evidence suggesting that Saudi caves contained beautiful formations like these.

يمين: يحتوي هذا الكهف على العديد من المتكونات الغريبة الجوفاء تشبه أعشاش الطيور.

أسفل: قبل إكتشاف دحل سلطان لم يكن هناك دليل على أن الكهوف السعودية تحتوي على هذه المتكونات الجميلة

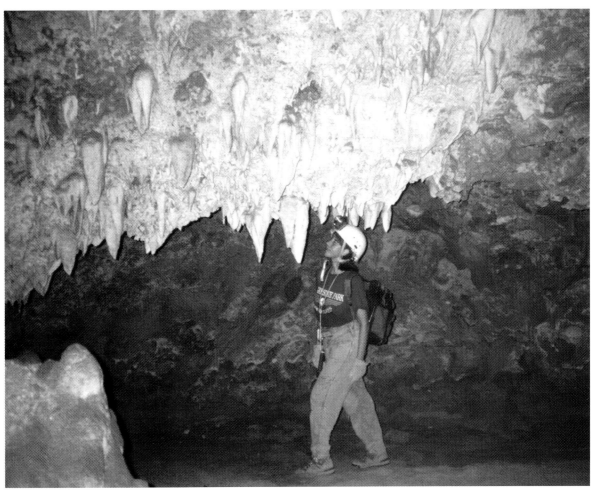

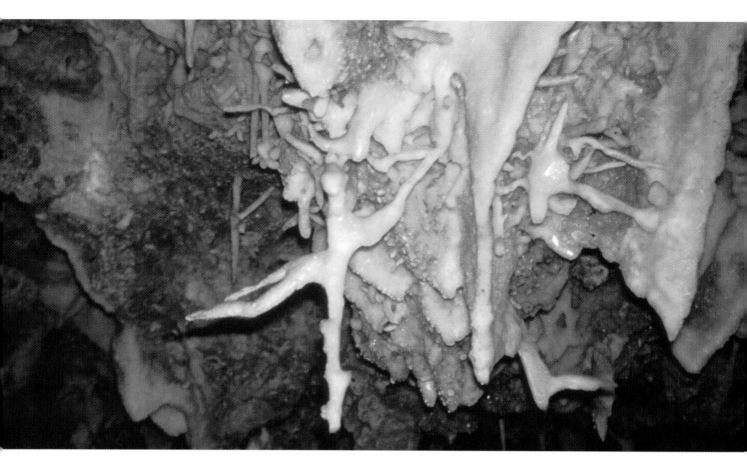

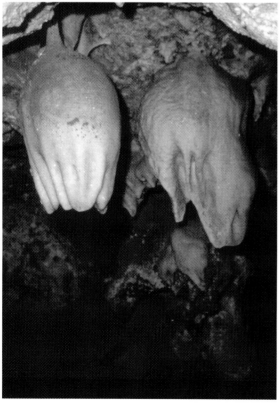

Above: instead of growing downwards, a helictite can go off in any direction. This one was named 'the Ice Dancer'.

Left: curiously shaped stalactites may remind the observer of flowers or animals.

Right: Dahl Sultan contains a maze of passages that may be several kilometres long.

أعلى: بدلاً من النمو نحو الأسفل فان الرواسب الكهفية العارجة يمكن أن تنمو في أي إتجاه. أطلق على هذه إسم (راقصة الجليد).

يسار: هذه الهوابط العجيبة الشكل تذكر المشاهد بزهور الحيوانات.

يمين: يحتوي دحل سلطان على شبكة من الممرات المعقدة التي يمتد طولها لعدة كيلو مترات.

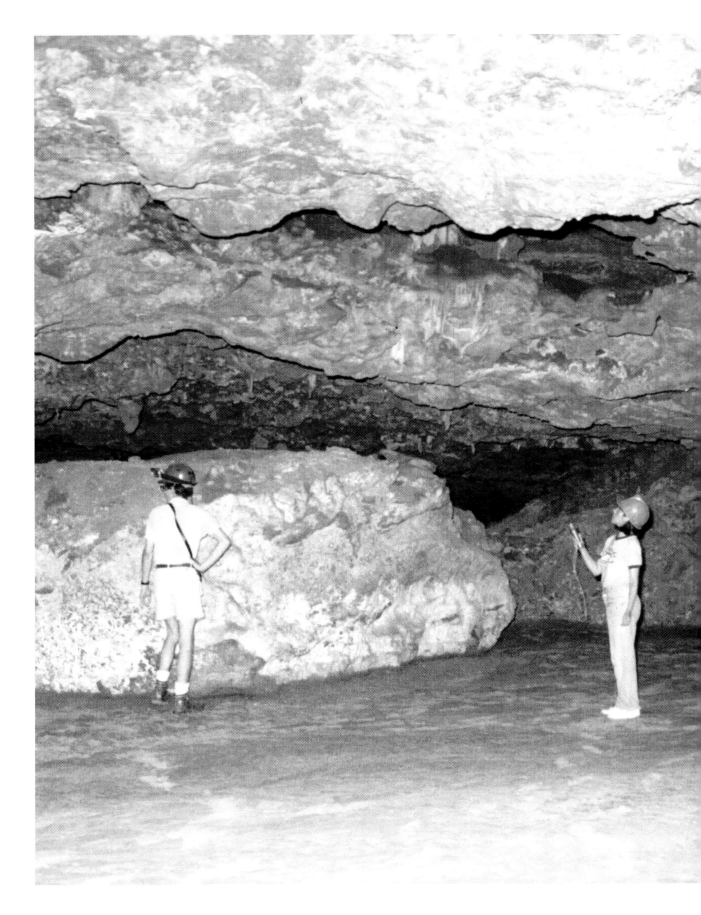

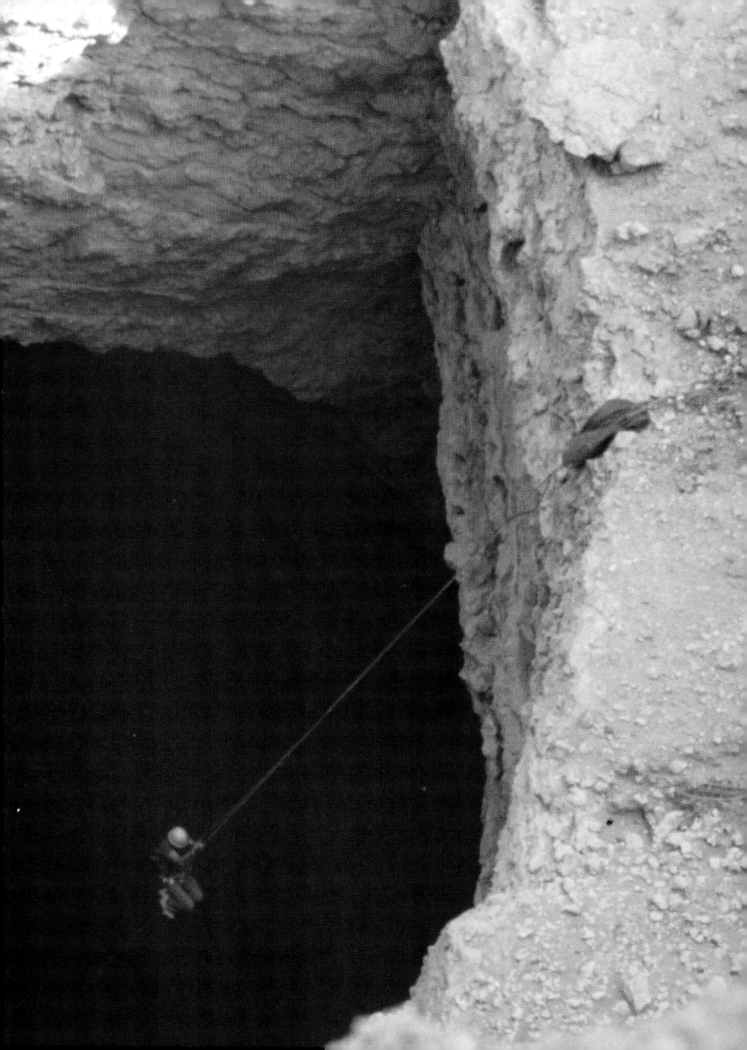

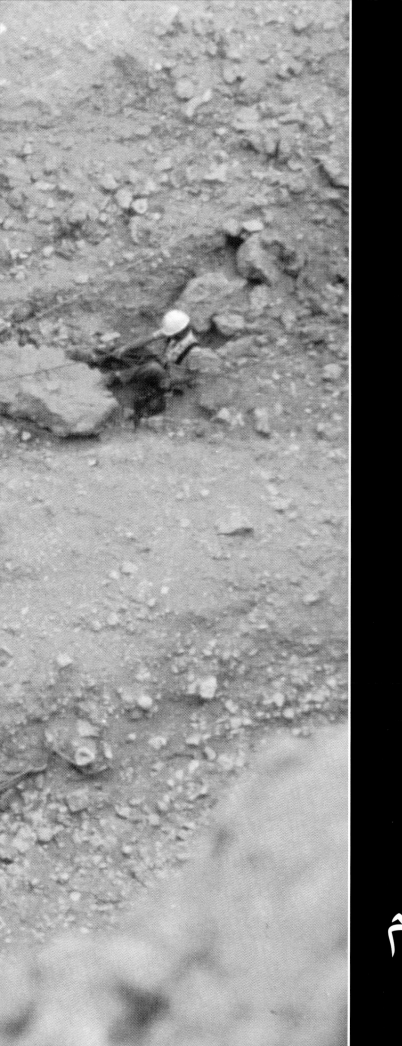

Dharb
Al Najem

درب النجم

The name Dharb Al Najem means Place Where the Star Fell to Earth and suggests how local people may have thought this great hole was created. Located in the desert east of Majma'ah, this cave consists of a single chamber roughly measuring 100 metres in depth by 100 metres in diameter. A person descending by rope into this huge room can only feel as small as a spider on a thread. Upon arriving at the bottom, he or she is treated to the awe-inspiring sight of a bright shaft of sunlight cutting through the darkness and lighting up the wings of hundreds of rock doves soaring overhead.

يدل الإسم "درب النجم" على مكان سقوط النجوم على الأرض ويوضح كذلك إعتقادات السكان المحليين حول تكوين هذه الحفرة الكبيرة. كونه قائماً في صحراء المجمعه الشرقيه، يتكون هذا الكهف من تجويف واحد يصل كل من عمقه وقطره إلى ١٠٠ متر. يشعر من يحاول النزول بواسطة الحبل إلى داخل هذه الغرفة الكبيرة كأنه عنكبوت معلق على شباكه. عند الوصول إلى الأسفل، يفاجأ المرء بشعاع الشمس اللامع البراق مضيئاً الظلمات ومنصباً على أجنحة حمام الصخور المحلقة عالياً.

Previous page: Dharb Al Najem is so deep that its first explorers couldn't tell whether their rope reached all the way to the bottom.

Opposite: in Saudi Arabia, speleologists can park their cars directly in front of a cave entrance, making it easy to anchor their ropes.

الصفحة السابقة: يتميز كهف درب النجم بعمقه الكبير لدرجة أن المستكشفين الأوائل لم يكونوا على يقين إذا كانت حبالهم قد بلغت القاع.

الصفحة المقابلة: في المملكة العربية السعودية يمكن لخبراء الكهوف إيقاف سياراتهم أمام مدخل الكهف مباشرة مما يسهل عملية تثبيت حبال النزول.

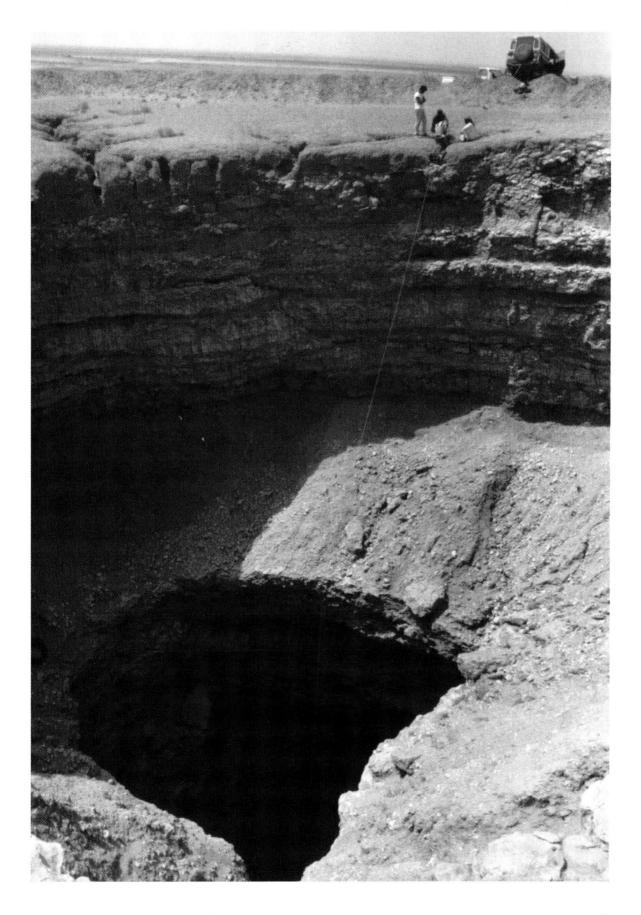

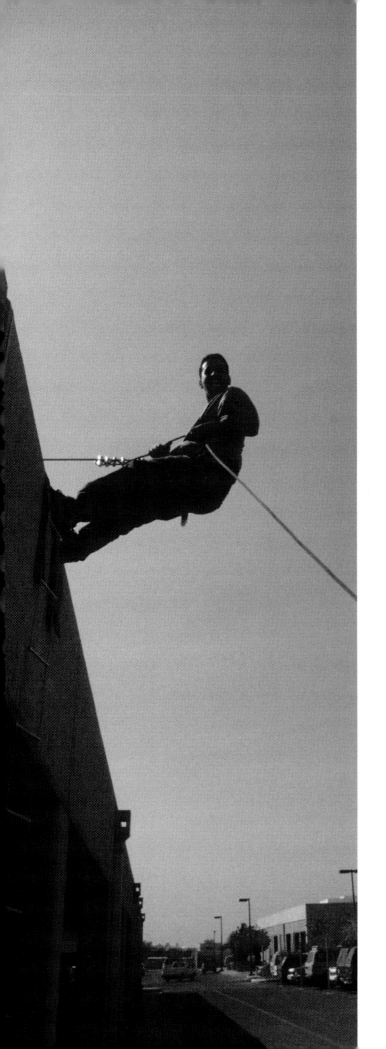

Technical preparation for long and dangerous rappels begins with lots of practice on buildings and trees.

تستدعي الاستعدادات الفنية لعمليات النزول الطويلة والخطرة القيام بالكثير من التمرينات على سطوح المباني والاشجار.

Right: a guide keeps watch over the rope while cavers are inside the pit.

يمين: دليل يراقب الحبل أثناء نزول المستكشفين إلى داخل الكهف.

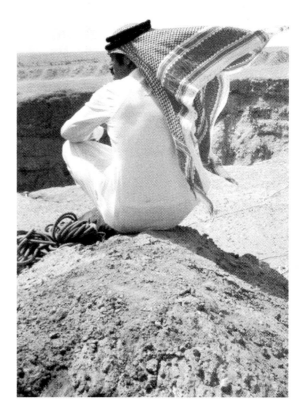

Below: curiously, the biggest underground chamber found in Saudi Arabia lies outside the Summan karst where most of the desert caves are located.

أسفل: مما يدعو للعجب أنه تم العثور على أكبر حجرة جوفية في المملكة العربية السعودية خارج هضبة الصمان التي توجد فيها غالبية الكهوف.

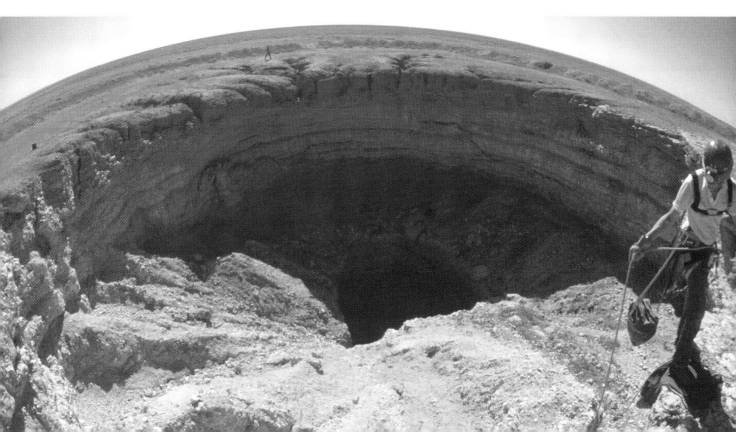

Left: acacia trees dot the landscape near the Dharb Al Najem pit, offering much appreciated shade to campers.

يسار: تواجد أشجار الأكاسيا بالقرب من حفرة درب النجم يؤمن الظل لرواد المخيمات الصحراوية.

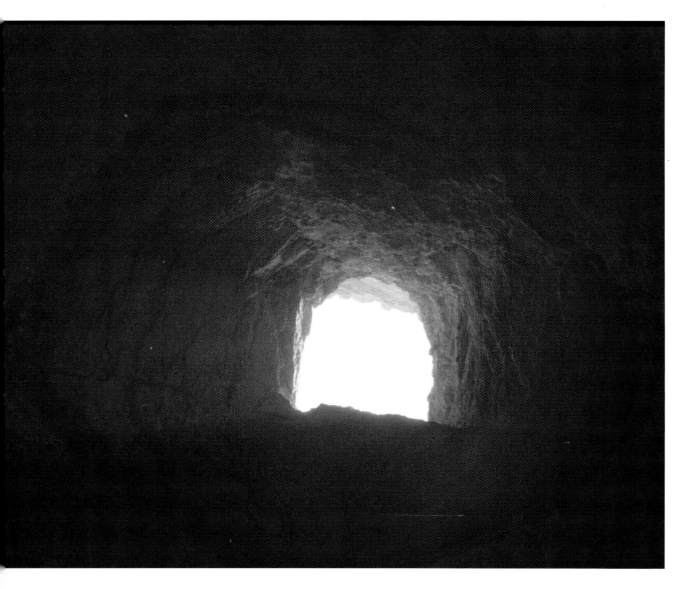

Below left: the nearly rectangular entrance to the pit, seen from 100 metres below, where the rope just barely touched the floor.

Below: stopping in Majma'ah to ask one man about the cave's location, John Pint soon found himself surrounded by helpful informants.

أسفل يسار: مدخل الحفرة شبه المستطيل كما يشاهد من على بعد ١٠٠ متر للاسفل حيث يلامس الحبل بالكاد أرضية الحفرة.

أسفل: خلال التوقف في المجمعة للسؤال عن موقع الكهف، وجد جون بنت نفسه محاطاً بمجموعة من الراغبين في تقديم المساعدة.

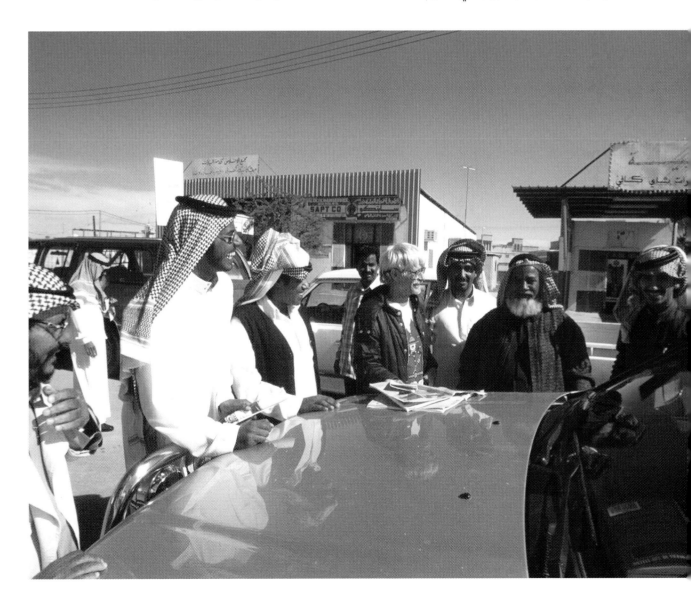

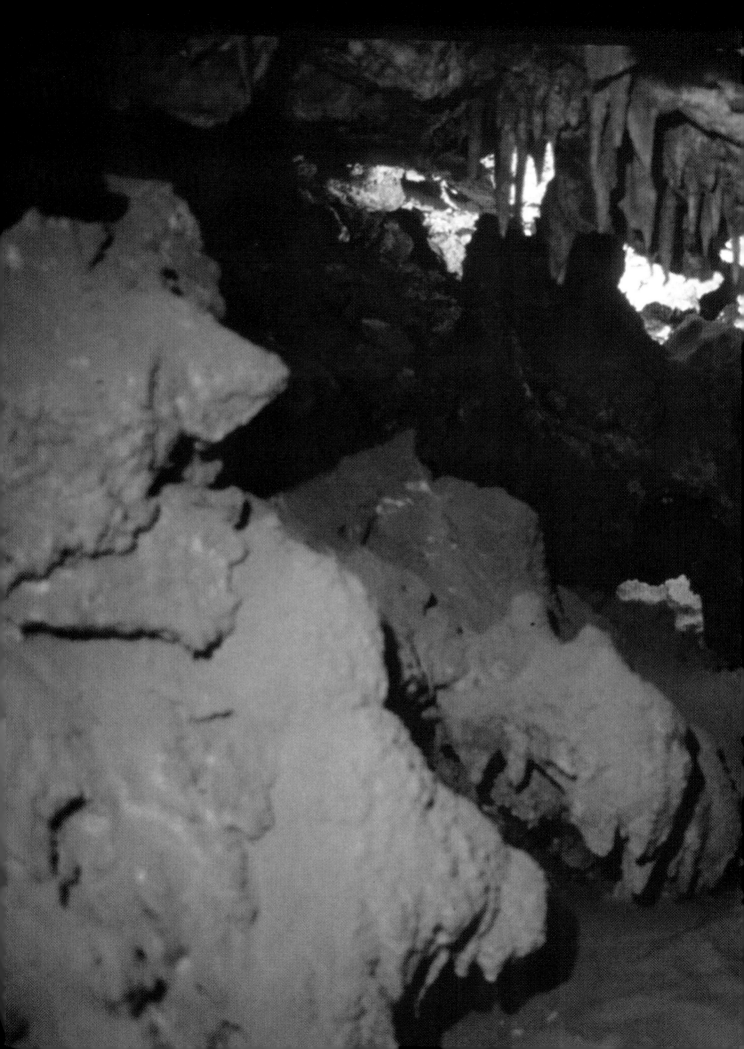

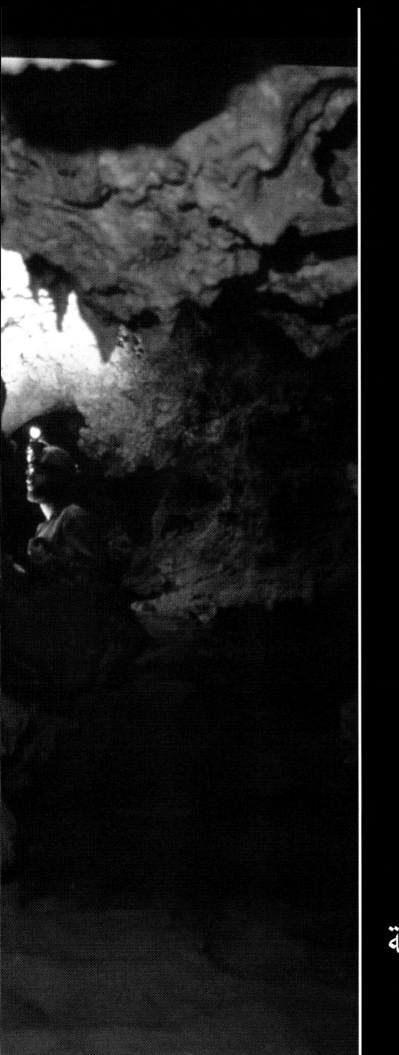

The KFUPM-Austrian Expedition Project

مشروع جامعة
الملك فهد
للبترول والمعادن
و البعثة النمساوية

In 1986 the Summan Plateau karst was chosen for an important study by scientists from King Fahd University of Petroleum and Minerals and the Austrian Academy of Sciences. The focus was on the role that dahls play in replenishing the large aquifer which supplies potable water to much of Saudi Arabia. During the course of this project, these investigators explored, studied and surveyed some 58 caves, amassing over 500 pages of documents and maps on this area of vital concern to Saudi Arabia's future.

في عام ١٩٨٦م تم إختبار هضبة الصمان للقيام بدراسة هامة من قبل علماء من جامعة الملك فهد للبترول والمعادن والاكاديمية النمساوية للعلوم وكان التركيز ينصب على دور الدحول في تغذية خزان الماء الجوفي الكبير الذي يمد المملكة العربية السعودية بالجزء الأكبر من مياه الشرب. وخلال تنفيذ هذا المشروع تم استكشاف ودراسة ومسح حوالي ٥٨ كهفاً مما نتج عنه إعداد ما يزيد عن ٥٠٠ صفحة من الوثائق والخرائط لهذه المنطقة ذات الاهمية الفائقة لمستقبل المملكة.

Previous page: after descending into B-15 Cave by cable ladder, speleologists found a meandering canyon with a sandy floor and bizarre rock formations.

الصفحة السابقة: بعد النزول إلى كهف ب–١٥ بواسطة الحبل المعدني، عثر علماء الكهوف على واد ضيق عميق ومتعرج وأرض رملية وصخور ذاتِ بذيه غريبة.

Opposite: preparations are made for water sampling inside Dahl An Nidu.

الصفحة المقابلة: تتم التجهيزات لأخذ عينات من الماء داخل دحل "الندو".

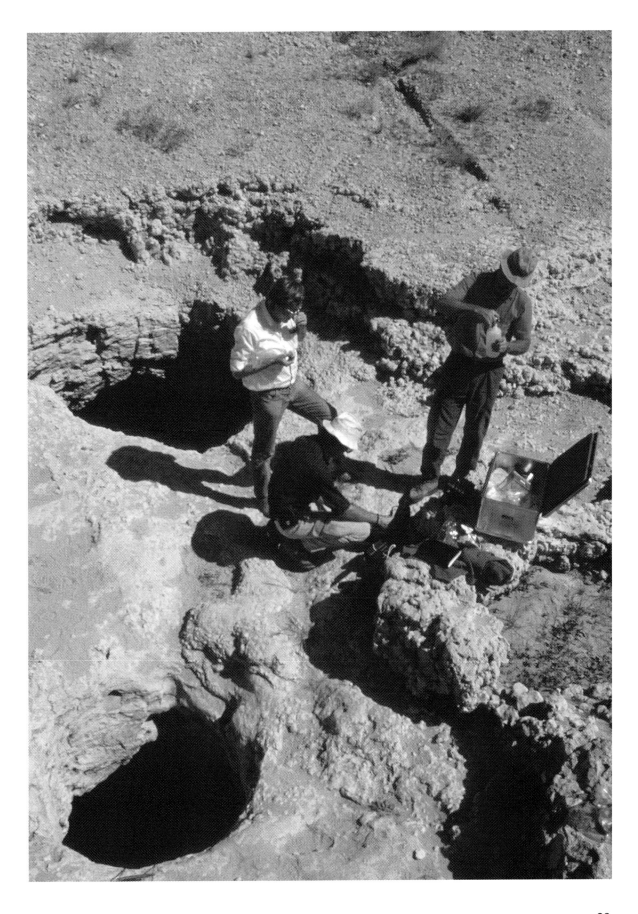

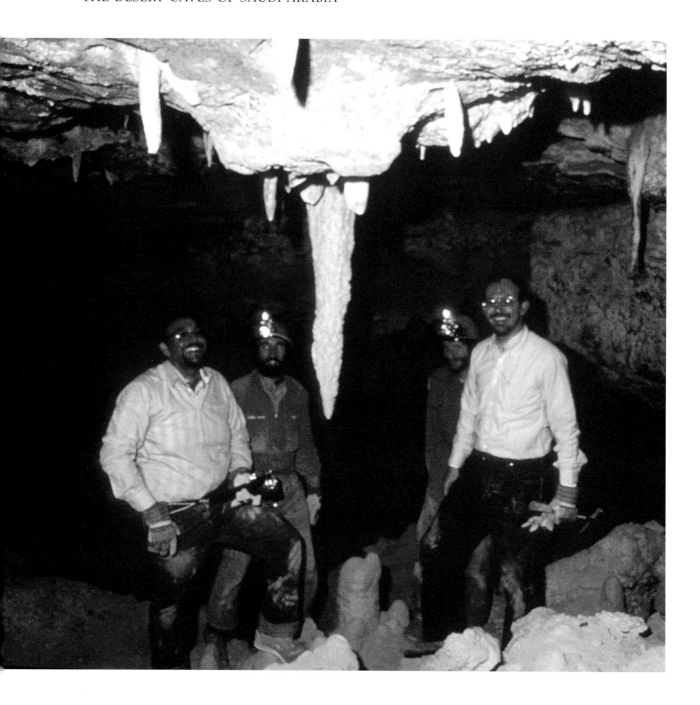

Above: Saudi and Austrian researchers admire one of the fine formations in Cave B-32.

Right: the thin roof of Dahl B-23. Scientists calculate that 45 per cent of the area's yearly rainfall reaches the aquifer deep below.

أعلى: الباحثون السعوديون والنمساويون يتأملون أحد المتكونات الجميلة في الكهف (ب-٣٢)

يمين: السقف الرفيع للدحل (ب-٢٣).يقدر العلماء ان ٤٥٪ من الامطار التي تسقط سنوياً على المنطقة تجد طريقها الى خزان الماء الجوفي في الاسفل.

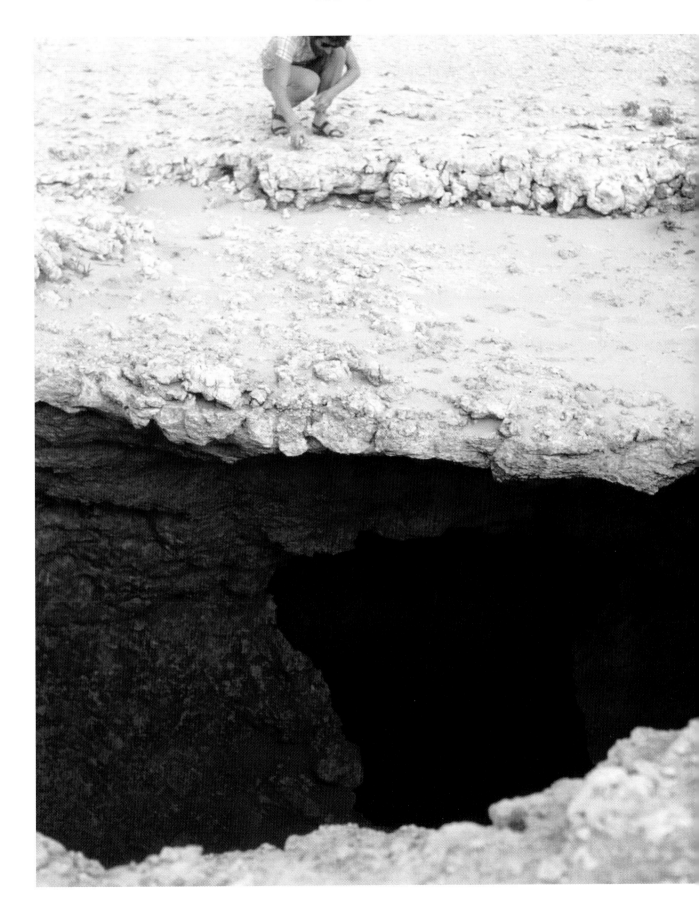

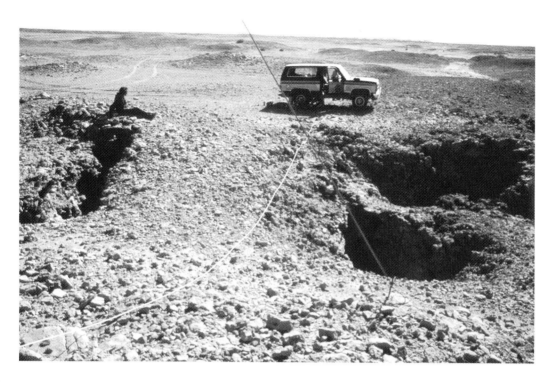

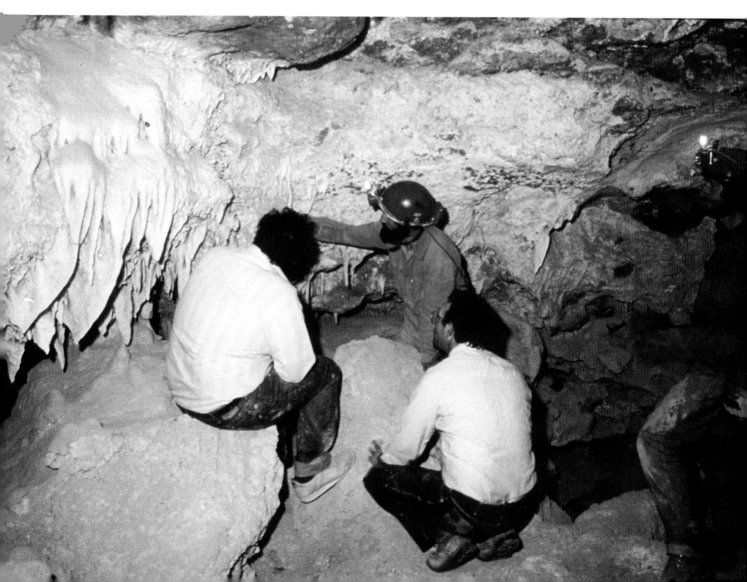

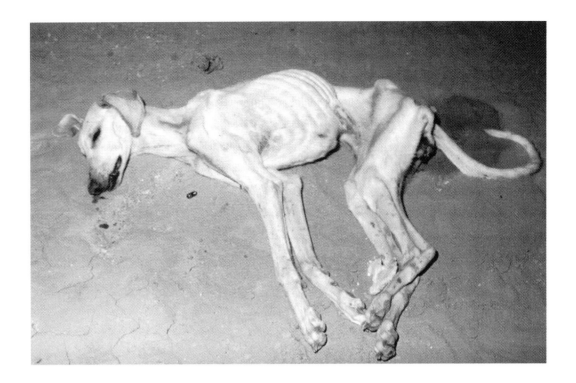

Top left: the entrances of Cave B-31. Hundreds of holes like these collect rain water in this karst area.

Above: the naturally mummified Saluki was found 90 metres from the entrance to Dog Cave.

Left: scientists discuss the speleothems of Cave B-32, which is 1.2 kilometres long and well decorated.

Right: finding the latitude and longitude of each cave required a large antenna and calculations based on satellites passing overhead.

أعلى اليسار: مداخل الكهف (ب-٣١) تجمع مياه الامطار داخل المئات من مثل هذه الحفر التي توجد في منطقة الكارست الموضحة في الصورة.

أعلى: كلب سلوقي محنط طبيعياً تم العثور عليه على بعد ٩٠ متراً من مدخل كهف الكلب.

يسار: يتناقش العلماء حول الرسابات الكهفية للكهف (ب-٣٢) الذي يبلغ طوله ١٫٢ كيلومتراً وتكثر فيه الزخارف.

يمين: تطلب تسجيل المدى العرضي والمدى الطولي لكل كهف الاستعانة بهوائي كبير وحسابات مبنية على الاقمار الاصطناعية العابرة فوق المنطقة.

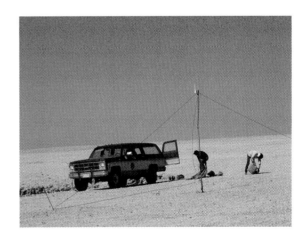

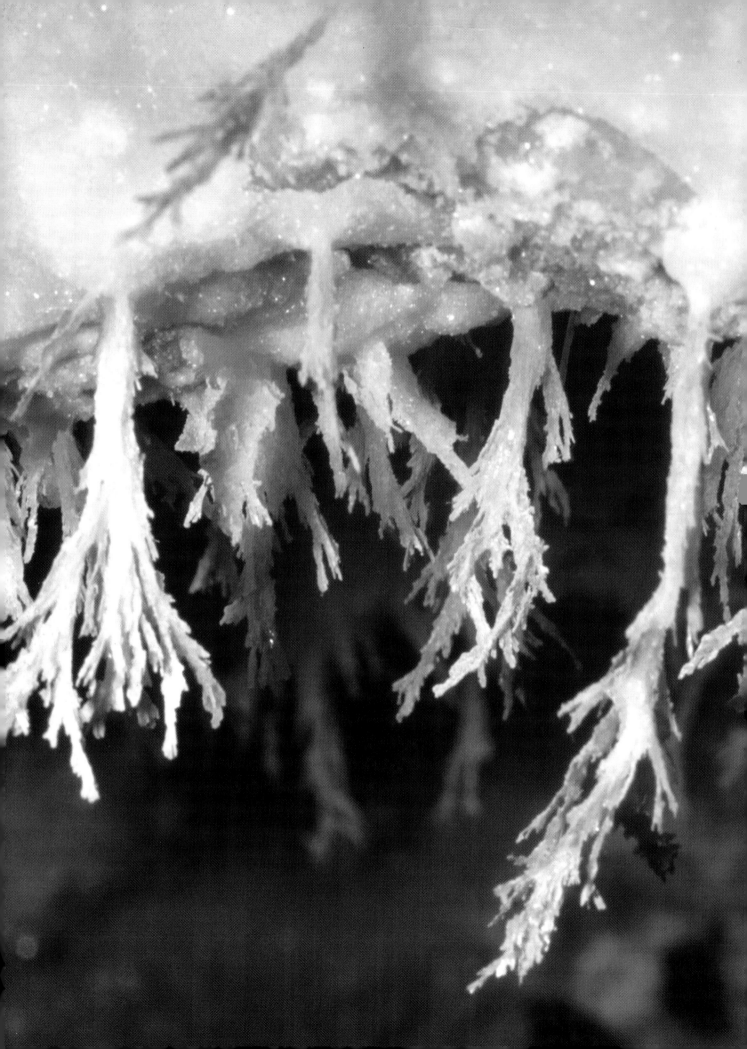

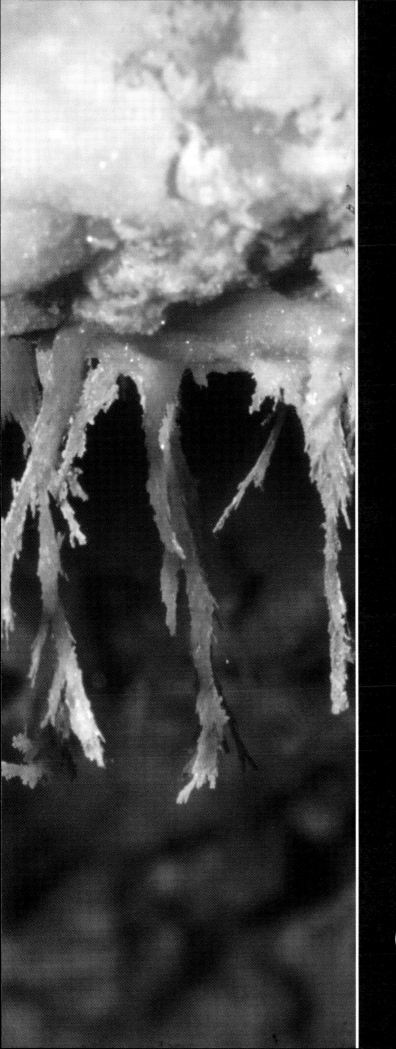

Treasures of
Dahl B-7/
Murubbeh

كنوز دحل

ب/٧ المربع

Many of the caves on the As Sulb plateau are warm and humid, but Dahl Murrubeh is dry and remains at a temperature of 16 degrees centigrade all through the year. This has provided the ideal ambient for preserving hundreds of bones carried into the cave by hyenas about a thousand years ago. Murubbeh also contains beautiful crystal formations not found in nearby caves. Because it has a walk-in entrance and a large room with a sandy floor, it has become a popular picnic spot and is in need of protection.

تتميـز العديـد مـن الكهـوف فـي هضبـة الصمّـان بأنهـا دافئـة ورطبـة، إلا أن دحـل المربـع جـاف وتسـوده درجـة حـرارة تبلـغ ١٦ درجـة مئويـة علـى مـدار السـنة ممـا جعلـه بيئـة مثاليـة لحمايـة مئـات العظـام التـي حملتهـا الضبـاع الـى داخـل الكهـف منـذ أكثـر مـن ألـف سـنة. ويحتـوي دحـل المربـع أيضـاً علـى متكونـات بلوريـة جميلـة لا توجـد فـي الكهـوف المجـاورة. ونظـراً لمدخلـه الواسـع ووجـود غرفـة كبيـرة ذات أرضيـة رمليـة بداخلـه فقـد أصبـح موقفـاً مفضـلاً للرحـلات البريـة ويحتـاج للحمايـة مـن العبـث بـه.

Previous page: resembling plants or frosted feathers, these calcite formations decorate the ceiling deep inside the cave.

Right: the last glimmers of sunlight illuminate the Camel Aisle, a long passage that leads to shimmering crystal formations.

الصفحـة السـابقة: تزيـن سـقف الكهـف هـذه المتكونـات الكلسـية التـي تشـبه النباتـات أو الريـش المكسـو بالجليـد

يميـن: الوميـض الأخيـر لاشـعة الشـمس يضـيء ممشـى الجمـل وهـو ممـر طويـل يـؤدي الـى متكونـات بلوريـة وامضـة.

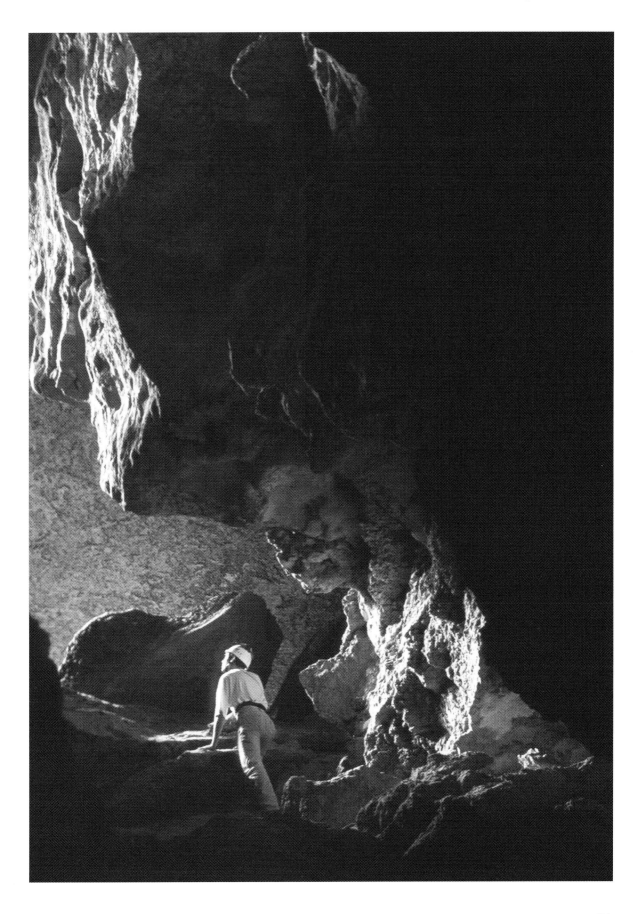

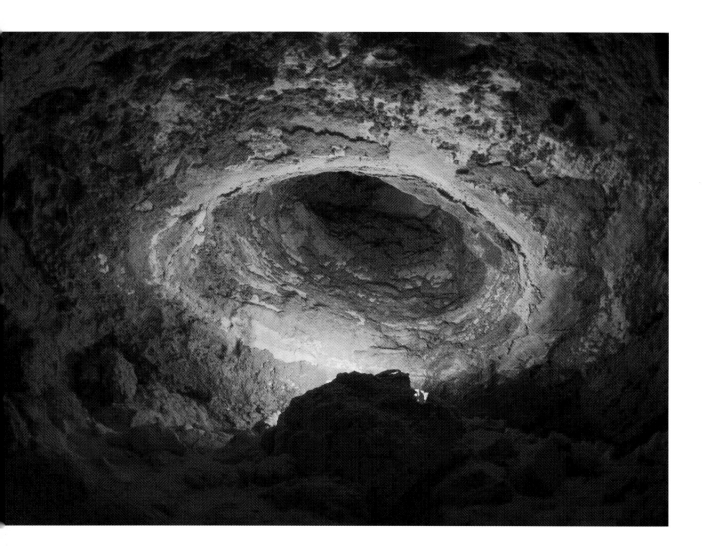

Above: a natural dome occurs halfway along the Camel Aisle. The nearby walls are covered with a thin lacy layer of calcite.

أعلى: قبة طبيعية تتواجد في منتصف ممشى الجمل تغطي الجدران القريبة طبقة شريطية رقيقة من الكلسيت.

Right: the first room in Dahl Murubbeh is fifty metres long and is home to owls, foxes and rock doves.

يمين: يبلغ طول الغرفة الاولى من دحل المربع خمسين متراً وهي مأوى لطيور البوم والثعالب وحمام الصخور.

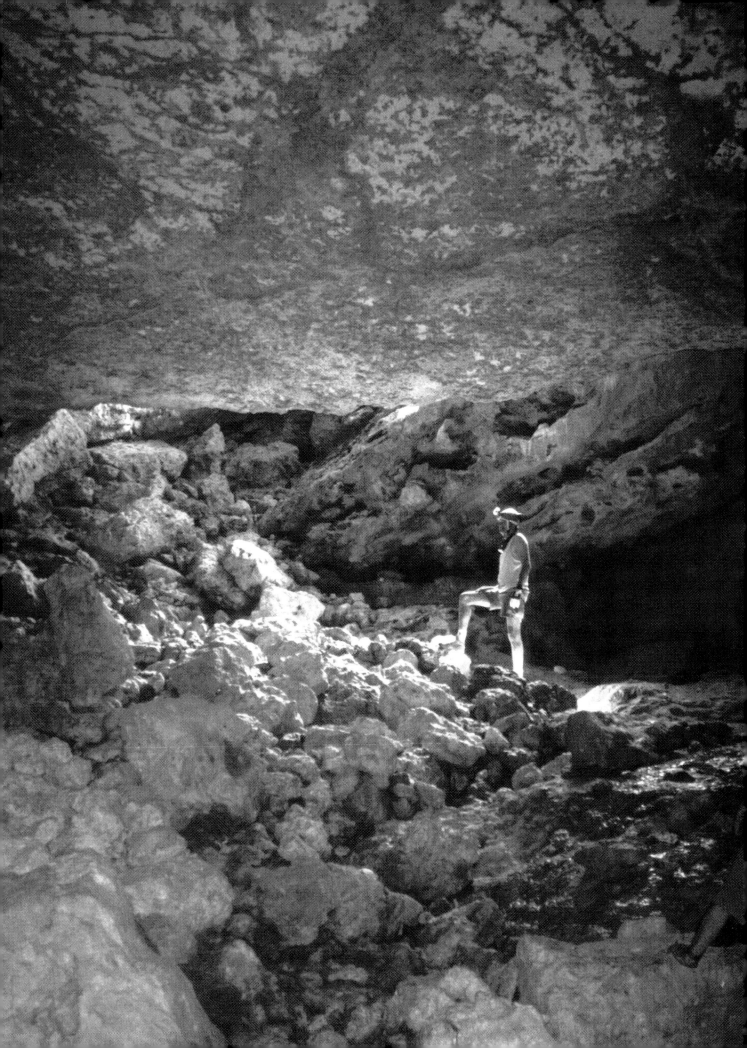

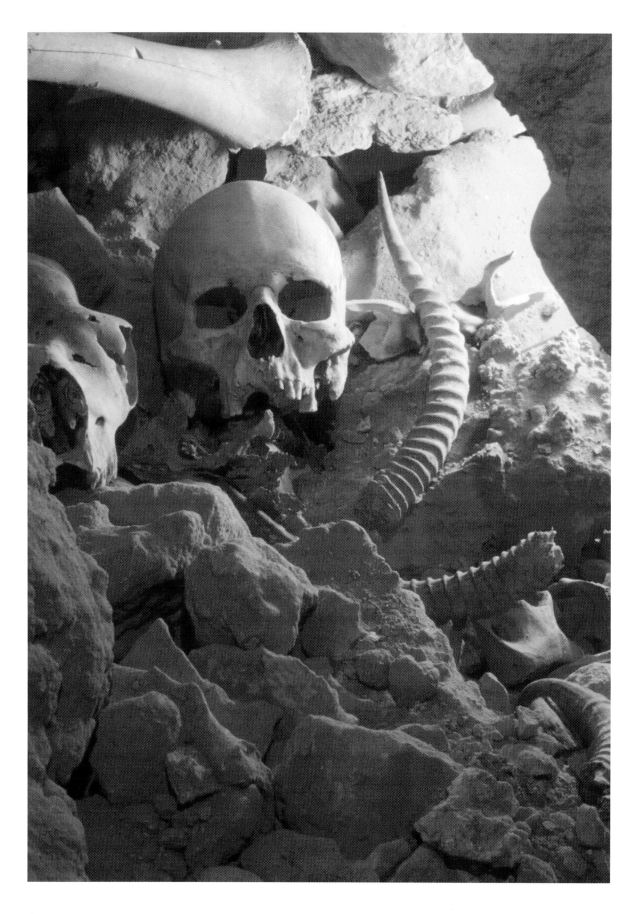

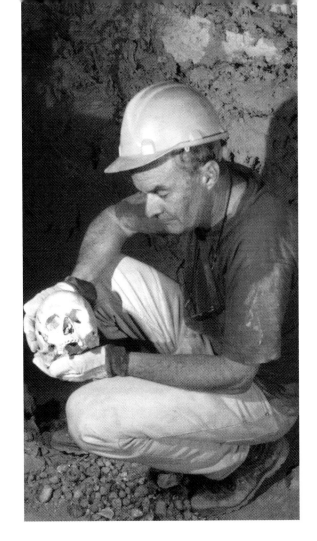

Far left: a human skull lies among bones and horns of a wide variety of animals. Tooth marks on the bones suggest they were carried into the cave by hyenas.

Left: a second skull was later found in a hidden room, deep inside the cave.

Below left: a bat, naturally preserved by the cool, dry air.

Below right: a naturally mummified Arabian red fox, carbon dated at 1900 years before the present.

اقصى اليسار: جمجمة بشرية وسط بقايا عظام وقرون لأنواع مختلفة من الحيوانات. وتوحي آثار الأسنان التي تظهر على الجمجمة أن ضباعاً قد حملتها إلى داخل الكهف.

يسار: وجدت الجمجمة الثانية مؤخراً في غرفة خفية في موضع عميق داخل الكهف.

اسفل يسار: خفاش محفوظ طبيعياً بواسطة الهواء البارد الجاف داخل غرفة العظام.

اسفل يمين: جثة محنطة طبيعياً لجلد ثعلب عربي أحمر اللون، كان يعيش قبل ١٩٠٠ عاماً حسب التاريخ الكربوني.

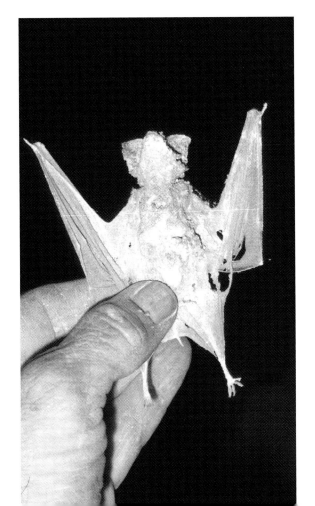

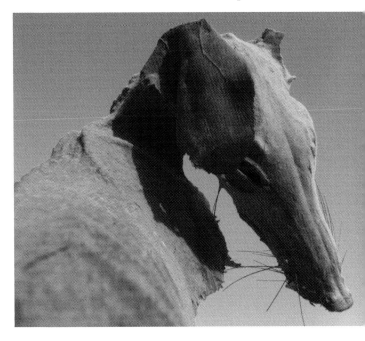

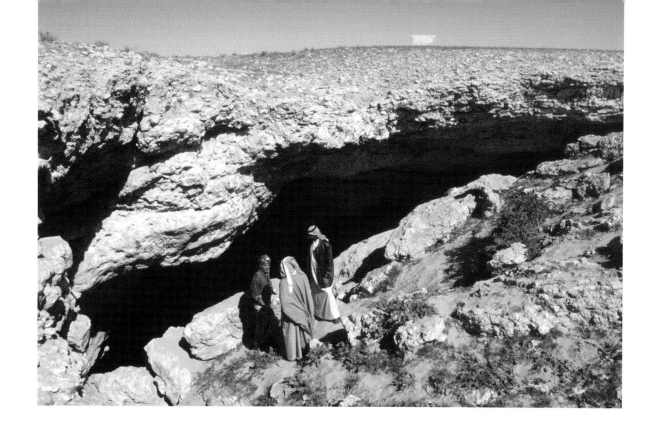

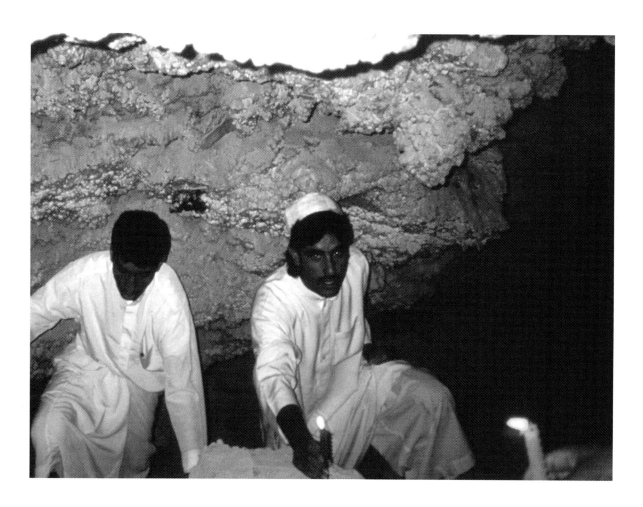

Left: an SGS geologist answers visitors' questions at the cave entrance.

Below: sunset at Dahl Murubbeh. Even in summer, the desert cools down at night.

يسار: جيولوجي من هيئة المساحة الجيولوجية السعودية يجيب على أسئلة الزوار عند مدخل الكهف.

أسفل: غروب الشمس عند دحل المربع. حتى خلال فصل الصيف فان درجة الحرارة في الصحراء تنخفض ليلاً.

Left: their candles dancing in the darkness like fireflies, local men investigate the wonders of Dahl Murubbeh.

يسار: تتراقص الشموع المضاءة التى يحملها أهالي المنطقة في الظلام مثل اليراعات وهم يتأملون غرائب دحل المربع.

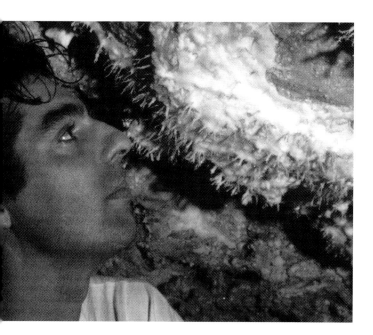

Above: the treasures of Dahl Murubbeh need to be protected so future generations can appreciate and study them.

Right: surveying the cool, wide, Camel-Aisle passage was a pleasure, compared to working in the hot, cramped conditions typical of many other desert caves.

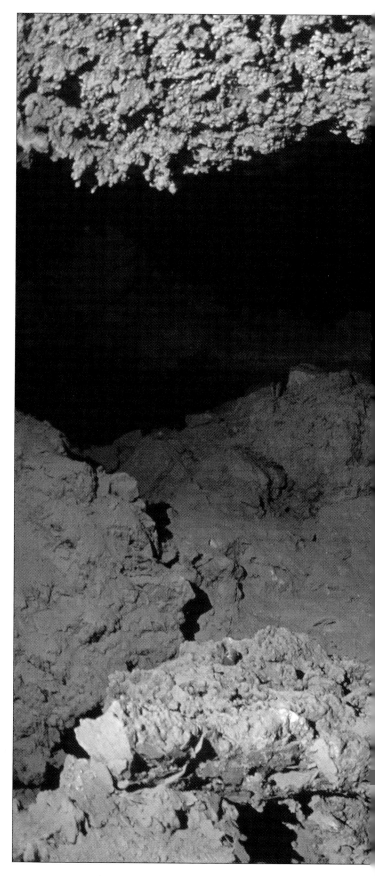

أعلى: تحتاج الكنوز التي يحتوي عليها دحل المربع إلى الحماية لكي تتمكن الاجيال القادمة من دراستها وادراك قيمتها.

يمين: مسح ممشى الجمل العريض الذي يمتاز باعتدال درجة حرارته مقارنة بالعمل تحت درجات الحرارة المرتفعة والمرهقة التي يختص بها العديد من الكهوف الصحراوية الاخرى.

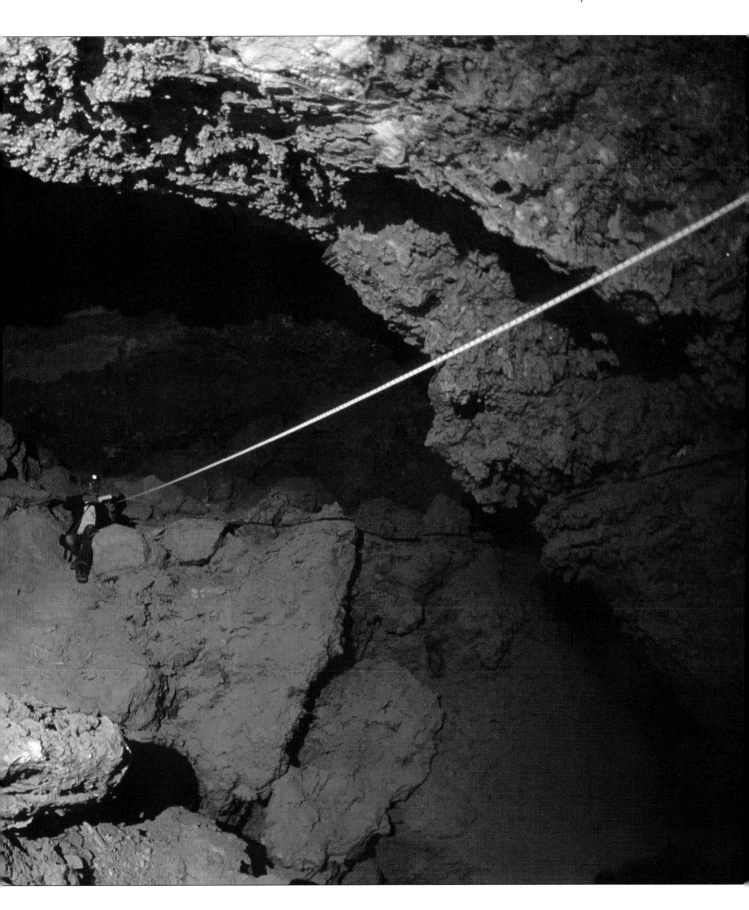

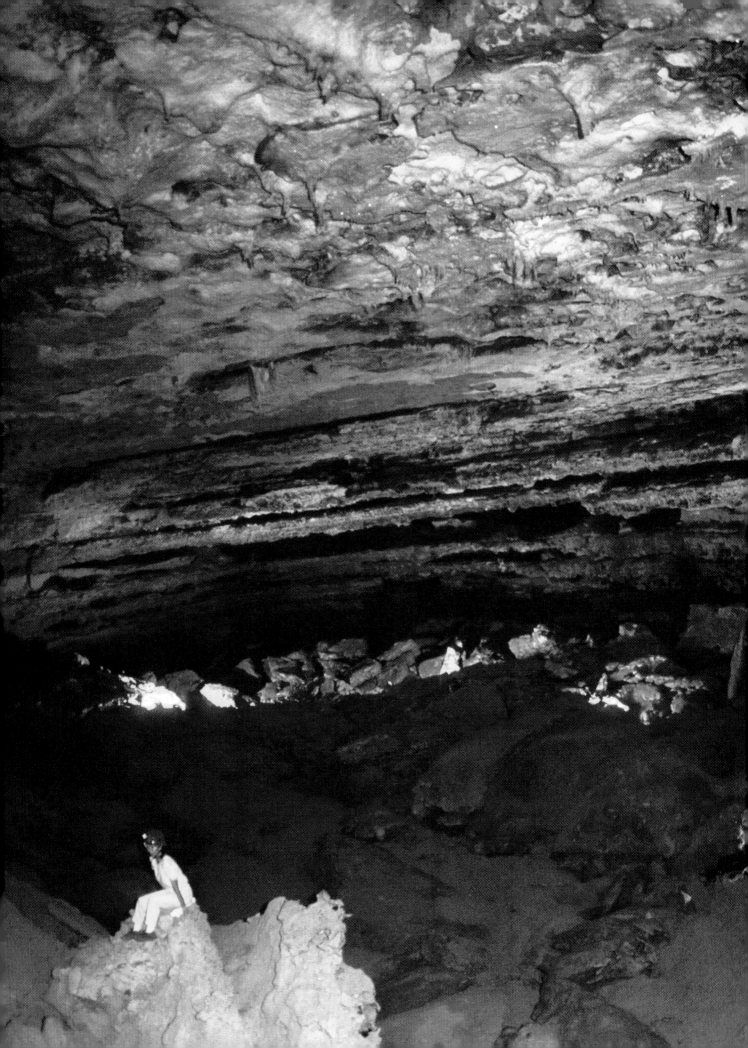

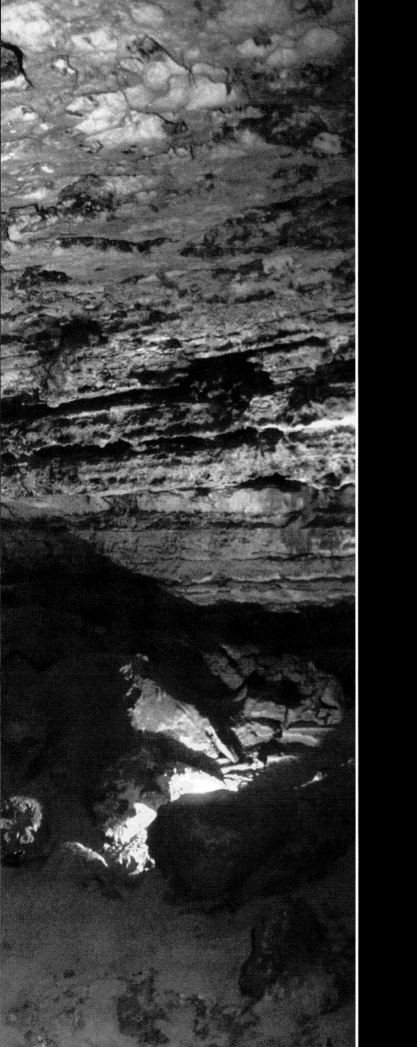

UPM
Cave

كهف جامعة
الملك فهد
للبترول
والمعادن

UPM Cave was one of the major discoveries made by speleologists from King Fahd University of Petroleum and Minerals and the Austrian Academy of Sciences. It has passages on three different levels and is impressive not only because of a huge hall (45 by 80 metres and 17 metres high) which once housed an underground lake, but also thanks to the delicate beauty of small formations such as tiny pools of cave pearls and an ever-growing rimstone dam. So far, speleothems of this sort have been found nowhere else in the Kingdom.

يعتبر كهف جامعة الملك فهد للبترول والمعادن من الاكتشافات الرئيسية للفريق المشترك لخبراء الكهوف من جامعة الملك فهد للبترول والمعادن والاكاديمية النمساوية للعلوم. يحتوي الكهف على ممرات في ثلاثة مستويات مختلفة وبداخله قاعة ضخمة (٤٥ متراً ٨٠. متراً وارتفاع ١٧ متراً) التي كانت تحتوي على بحيرة جوفية في الماضي. توجد بالقاعة حالياً متكونات صغيرة جميلة الشكل مثل برك لآلئ الكهوف وسد الحجر الطوقي المتنامي. وحتى الآن لم يتم العثور على مثل هذا النوع من الترسبات الكهفية في أي موقع آخر في المملكة.

Previous page: the huge hall lies 26 metres below the surface. Water accumulating here slowly seeps down to the aquifer.

الصفحة السابقة: القاعة الضخمة التي تقع على مسافة ٢٦ متراً تحت السطح. يتسرب الماء الذي يتجمع هنا للأسفل تدريجياً ليغذي خزان المياه الجوفي.

Right: a skilled climber can get in and out of UPM Cave without a ladder, but a belay or safety line is a must.

يمين: يمكن لأي متسلق ماهر ان يدخل الى كهف جامعة البترول والمعادن ويخرج منه دون استخدام سلم ولكن وجود حبل السلامة أمر ضروري.

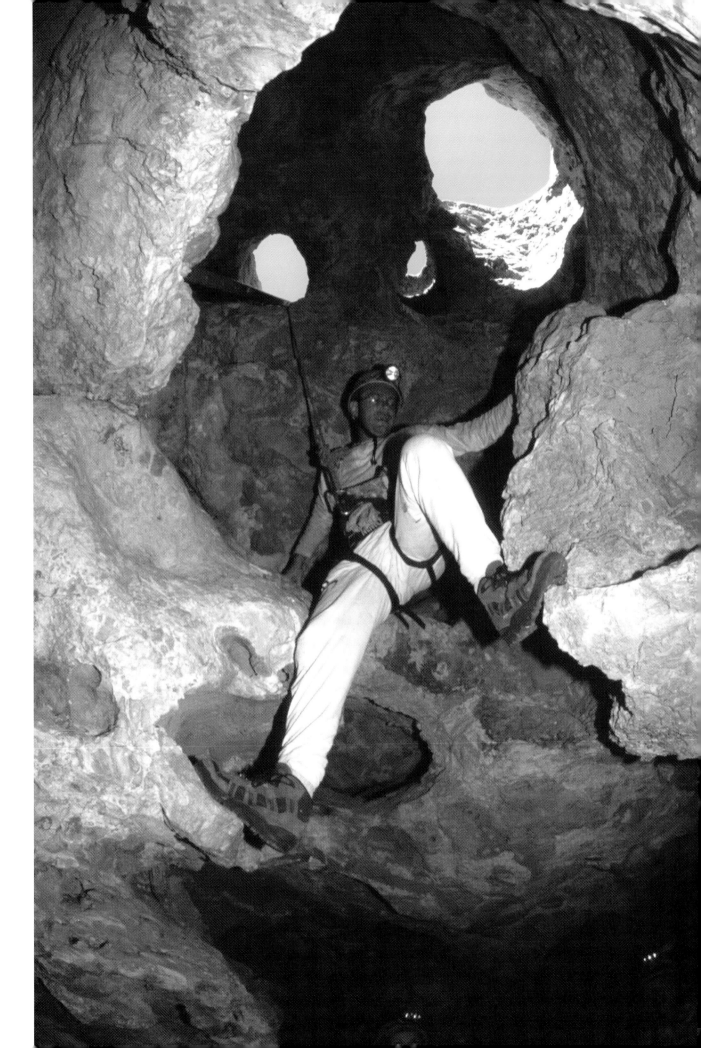

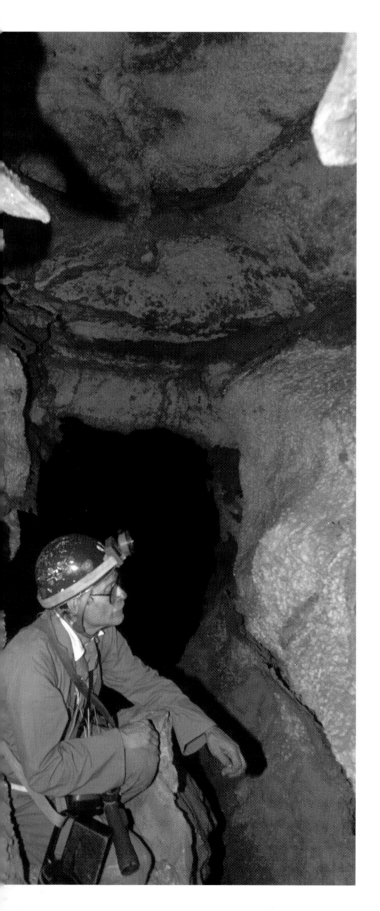

Left: anything that cavers use frequently is attached to their person by a cord or a strap.

Right: just beyond this balcony off the huge hall lies a horizontal passage 220 metres long.

يسار: يتم ربط كل مايحتاجه خبير الكهوف الى جسمه بواسطة حبل أو طوق (حزام).

يمين : بعد هذه الشرفة مباشرة المتفرعة عن القاعة الضخمة يوجد ممر أفقي طوله ٢٢٠ متراً.

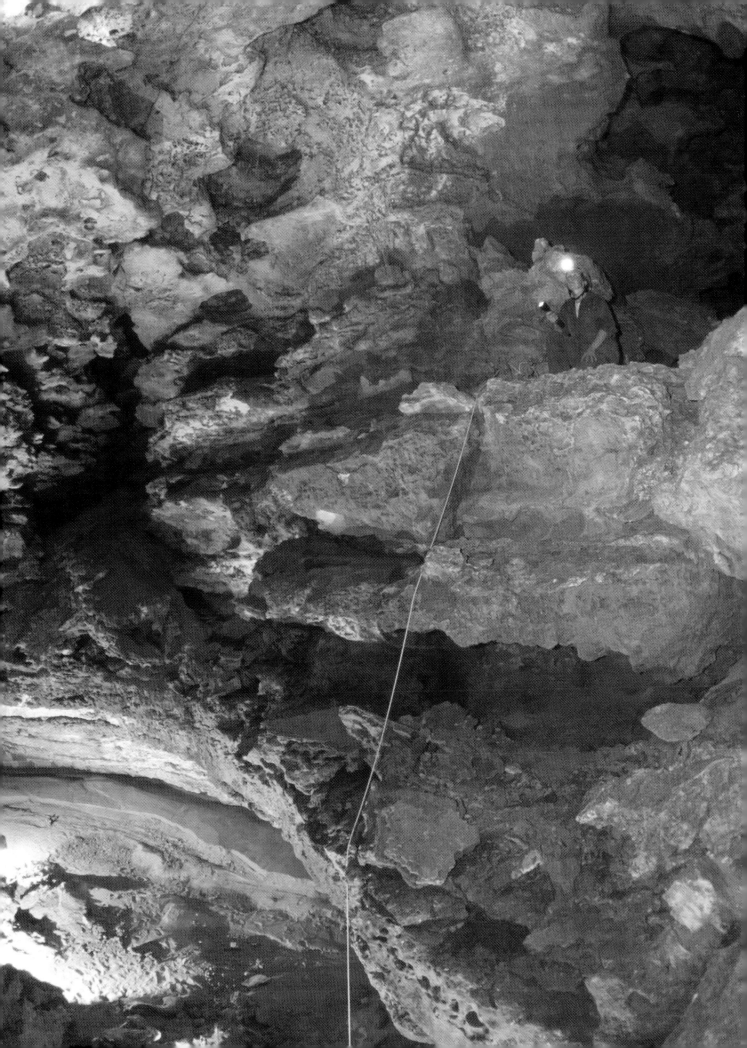

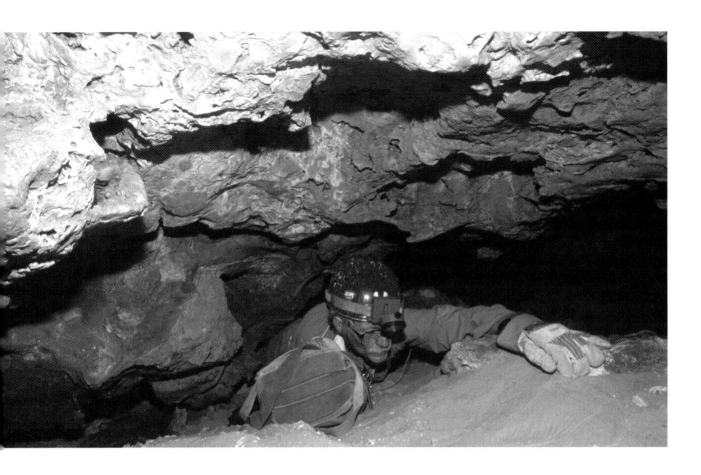

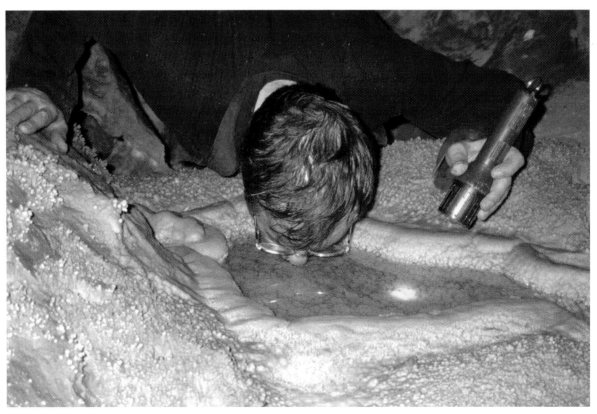

Left: a belly crawl is necessary for reaching the large passages. Tripods, lanterns and other gear must follow the same route.

Below left: water dripping from the ceiling has created a rimstone dam, of small, sparkling crystals.

Below: whenever a heavy rain falls in this area, a great deal of water makes its way down the six entrances of UPM Cave.

Above: dahls are often less than 15 metres deep, making a cable ladder the most practical instrument for visiting Saudi caves.

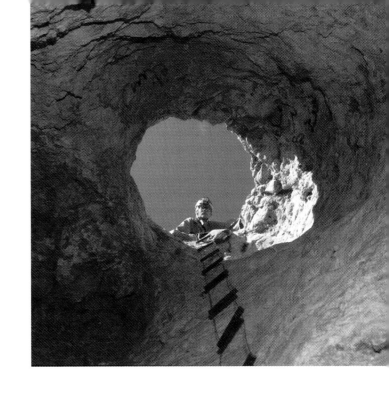

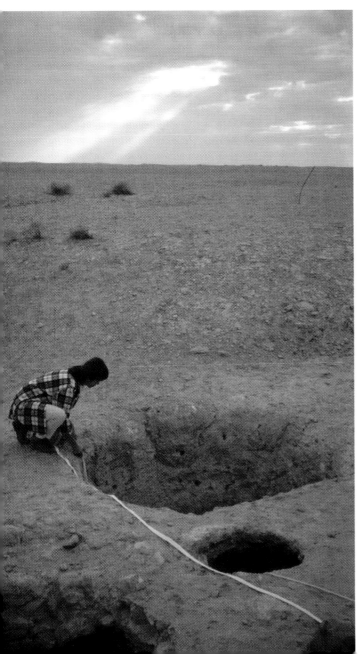

أعلى: تبلغ أعماق الدحول أحياناً أقل من ١٥ متراً وبالتالي فإن السلم المعدني هو الجهاز العملي لزوار الكهوف السعودية.

أسفل: عند هطول أمطار غزيرة في هذه المنطقة يتسرب جزء كبير من المياه للأسفل عبر المداخل الستة لكهف جامعة البترول والمعادن.

يسار: لابد من الزحف على البطن للوصول إلى الممرات الكبيرة ويتم إدخال المصابيح وقوائم آلات التصوير والأدوات الأخرى عبر الممر نفسه.

أسفل يسار: شكلت المياه الساقطة من السقف سداً من الحجر الكلسي المؤلف من بلورات صغيرة متلألئة.

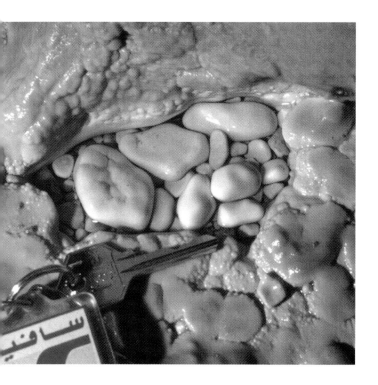

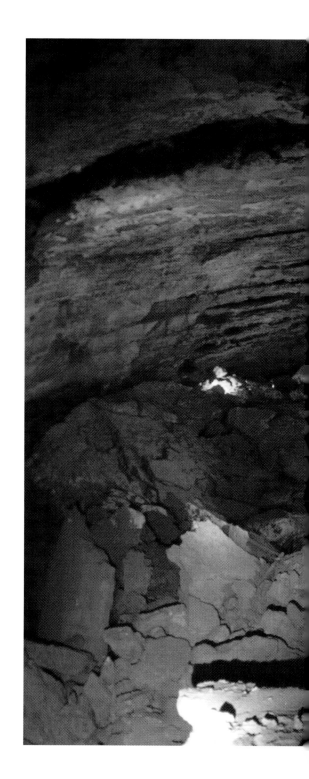

Above: cave pearls are small stones that have been coated with a layer of smooth, milky calcite. These are still growing, even though the cave is located in a desert.

Right: once upon a time, when rain was more abundant, this large room contained an underground lake.

أعلى: لآلئ الكهوف عبارة عن حجارة صغيرة مطلية بطبقة لامعة وناعمة من "الكالسيت" الحليبي اللون وهي لاتزال تنمو على الرغم من موقع الكهف في الصحراء.

يمين: في قديم الزمان، عندما كانت الأمطار تسقط بغزارة، كانت هذه الغرفة الواسعة تحتوي على بحيرة جوفية.

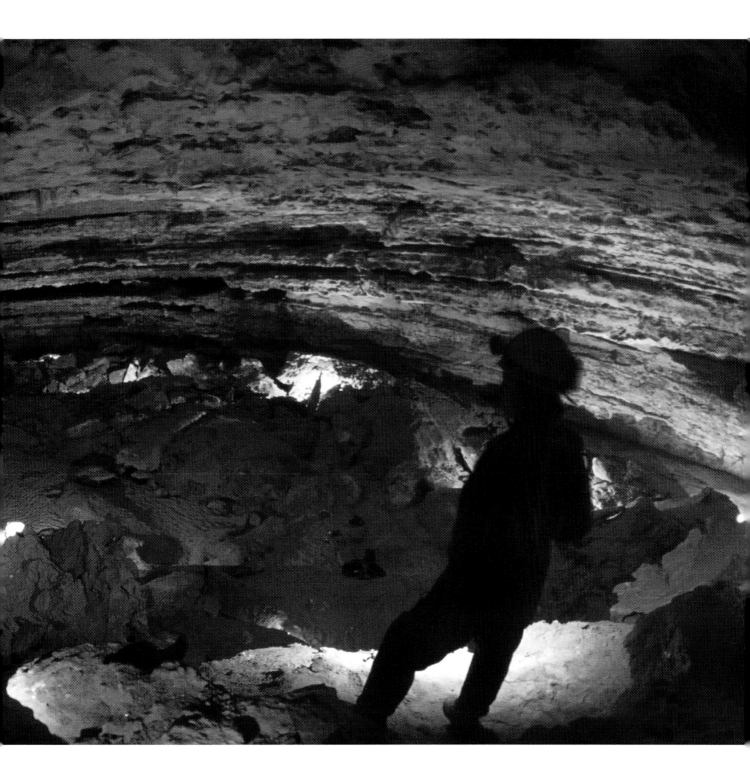

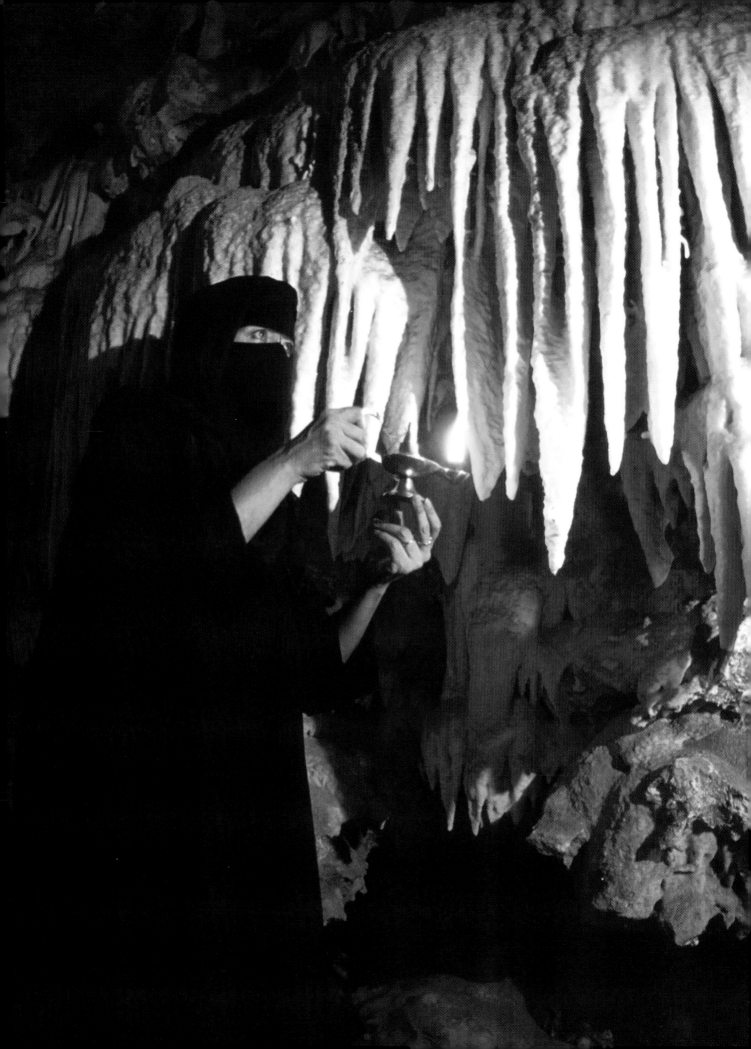

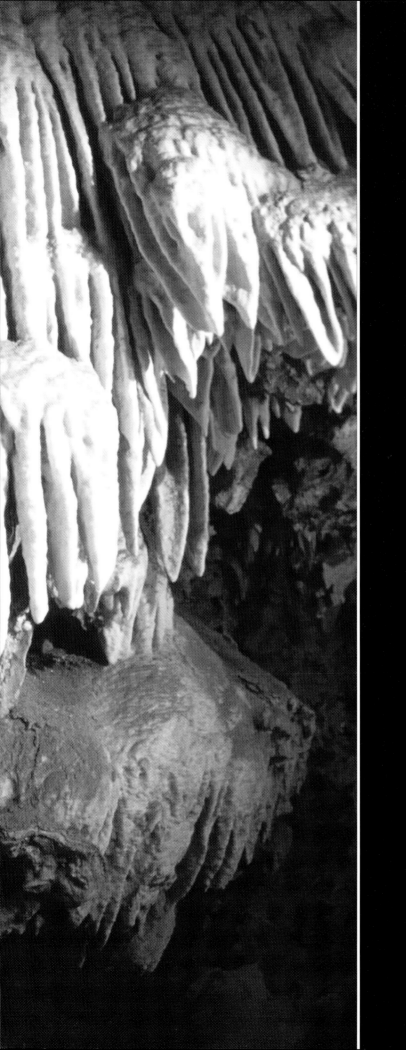

Mossy Cave

كهف لطحلب

This cave was discovered by accident when a group of explorers took a shortcut in order to recover a lost flashlight. Bright green moss, which is not something one expects to find in a parched desert, caught the cavers' eyes and led them to a baroque world of gaudy, crystalline draperies and tiny intricate tangles of helictites. One of its most outstanding formations, a very long stalactite called The Rope, was accidentally smashed not long after Mossy's discovery. Visits to such caves should be limited to very small groups of responsible adults.

تم اكتشاف هذا الكهف بالصدفة عندما كانت مجموعة من المستكشفين تبحث عن مصباح كشاف في إحدى الطرق الفرعية، ولفت أنظارهم وجود طبقة من الطحلب الأخضر الناصع، وهي ظاهرة لايتوقع المرء أن يشاهدها في صحراء قاحلة. وتم اكتشاف عالم مزخرف من الستائر البلورية المتشابكة، ومجموعات دقيقة معقدة من الترسبات المتعرجة. كما اكتشف أحد أهم متكونات الكهف وهو عبارة عن هابط طويل للغاية أطلق عليه اسم (الحبل) الذي تقطع بعد فترة وجيزة من اكتشاف الكهف. لذلك يجب أن تقتصر زيارة مثل هذه الكهوف على مجموعات صغيرة جداً من البالغين.

Previous page: unperturbed by the mosquitoes and sand flies sometimes found in Mossy Cave, this visitor admires a flowstone display.

Opposite: when are they coming out? Warm air bathes a worried assistant peering down the moss-covered entrance to the cave.

الصفحة السابقة: يستمتع هذا الزائر بمشاهدة جمال حجر الانسياب الكهفي داخل كهف الطحلب غير عابئ بوجود الناموس والذباب الرملي.

الصفحة المقابلة: متى سيخرجون؟ أحد المساعدين يتصبب عرقاً من الحر وهو يطل داخل مدخل الكهف المغطى بالطحلب.

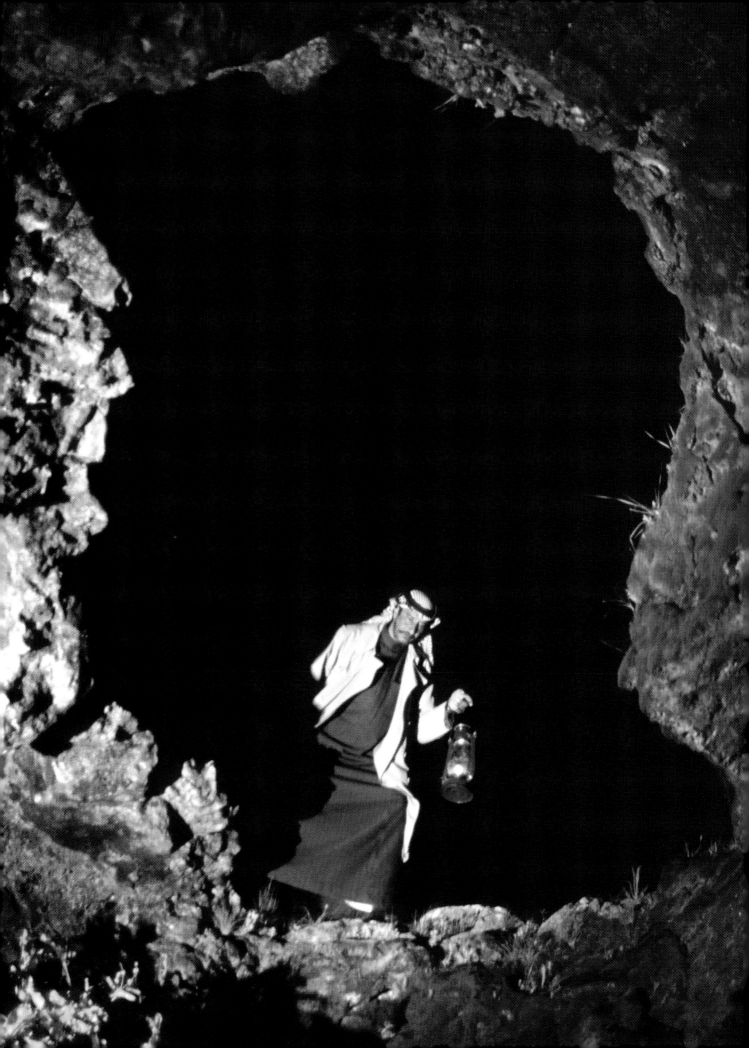

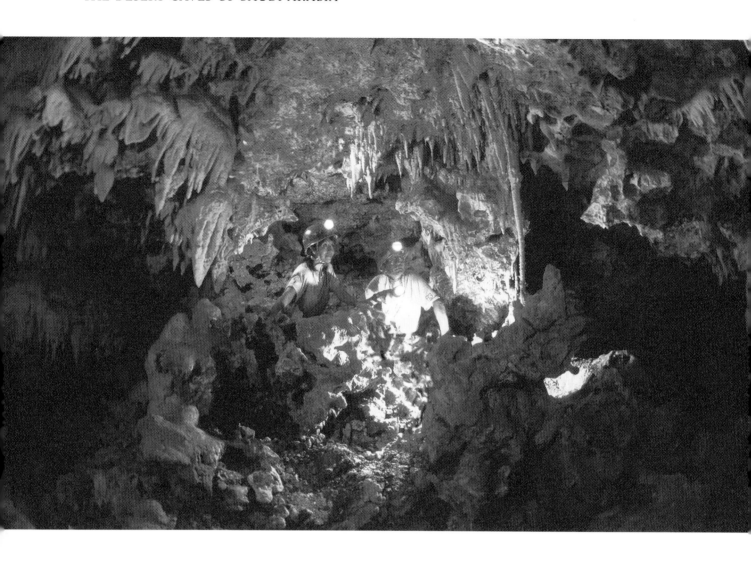

Above: these cavers are looking at The Rope, an outstanding stalactite which was subsequently broken by an unknown visitor to the cave, never to be seen again.

Top right: strangely shaped stalactites and stalagmites abound in Mossy Cave. This formation is known as the Ice Pick.

Right: great care must be taken while moving through this cave. Fragile formations may be found overhead as well as underfoot.

أعلى: ينظر هؤلاء المستكشفون إلى (الحبل) وهو هابط ضخم (مكون من ترسبات كلسية مدلاة من سقف الكهف). وقد تهشم في وقت لاحق على يد زائر مجهول للكهف.

أعلى اليمين: هوابط و صواعد غريبة الاشكال داخل كهف الطحلب ويعرف هذا المتكون باسم "معول الثلج".

يمين: يجب اتخاذ الحيطة عند التنقل عبر هذا الكهف، فالمتكونات الهشة قد توجد عند السقف بمحاذاة الرأس، وفي الأسفل على الأرضية بين الأقدام.

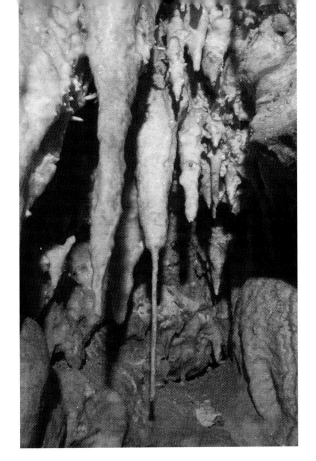

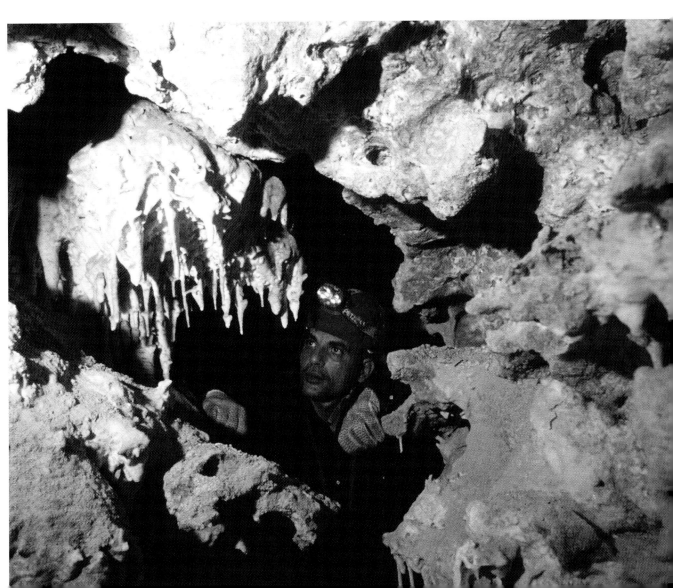

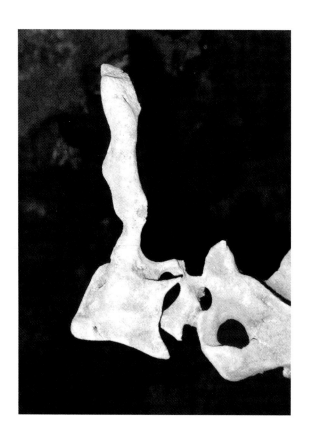

Left: bizarre shapes reach out from the cave wall, snagging the clothes of unwary visitors.

Right: Mossy Cave is climbable, but tricky. Mining engineer Dave Canning demonstrates the right moves.

Below: Mossy Cave has neither smooth walls nor a flat floor.

Below right: these stalactites are known as the Organ Pipes.

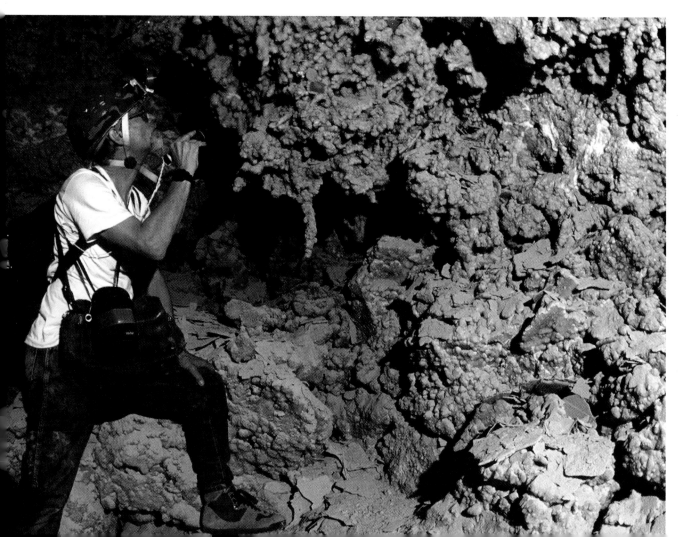

يسار: أشكال غريبة تمتد إلى الخارج من جدار الكهف وتعْلق بملابس الزائر دون ان يشعر بذلك.

يمين: يمكن تسلق كهف الطحلب، ولكنها عملية خطيرة يقوم الجيولوجي ديف كاننق بشرح الخطوات الصحيحة.

اسفل: لا يحتوي كهف الطحلب على جدران ناعمة أو أرضية مسطحة.

اسفل يمين: تعرف هذه الهوابط باسم (أنابيب الأرغن).

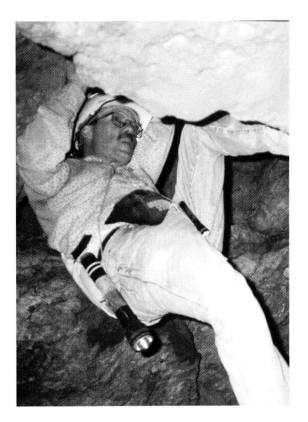

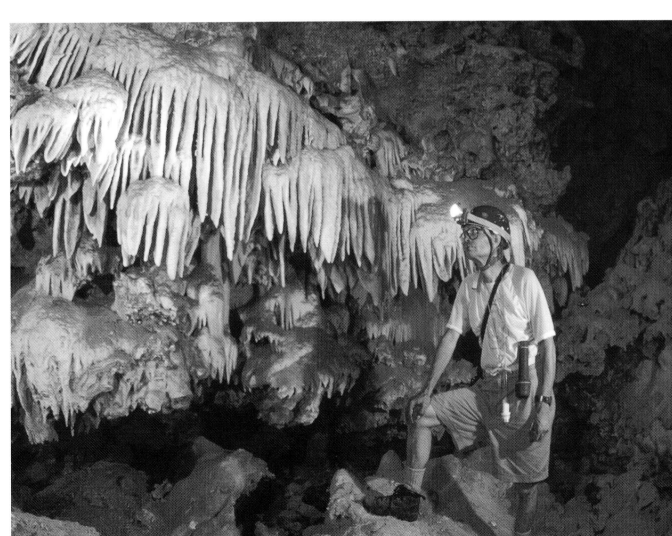

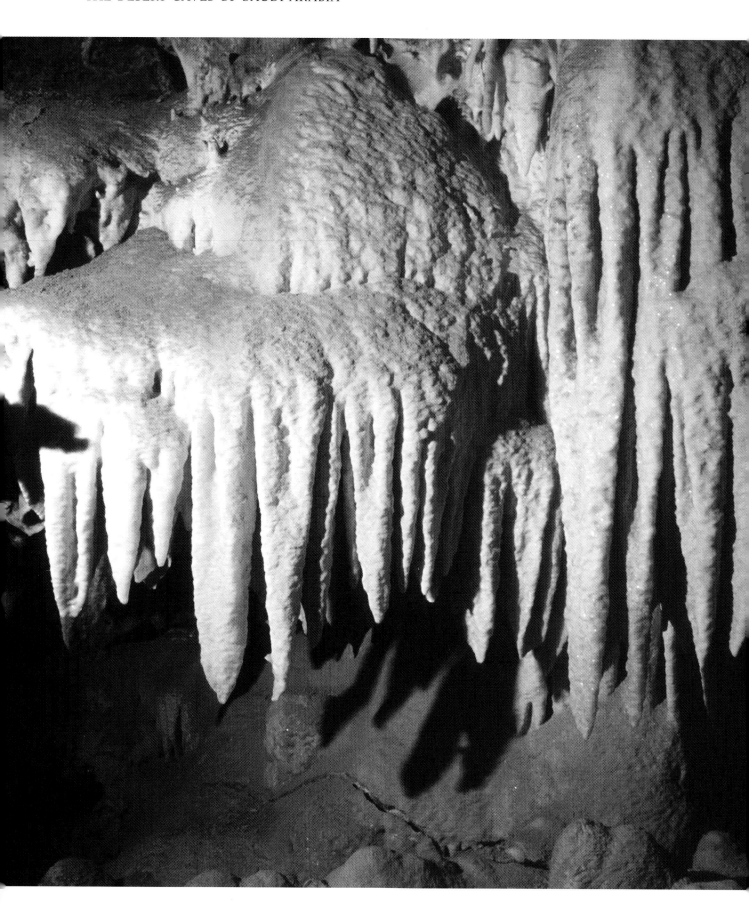

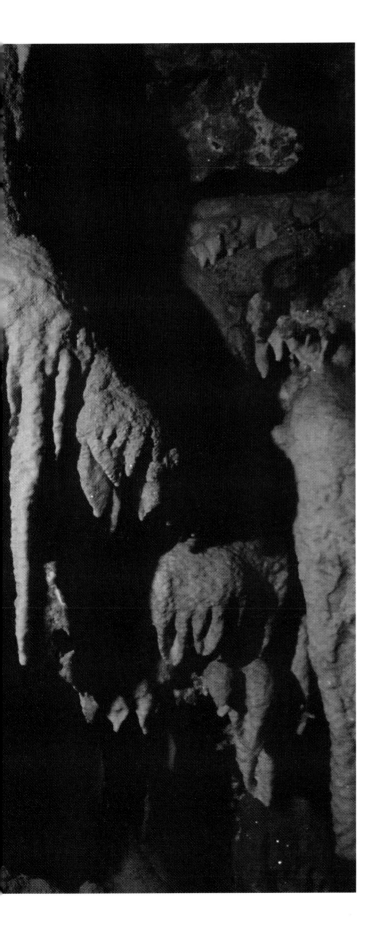

Stalactites and stalagmites in the Summan Karst can be over 400,000 years old, but they can be broken in just a second.

ظلت الهوابط و الصواعد موجودة في هضبة الصمّان لما يزيد عن ٤٠٠،٠٠٠ سنة ولكن يمكن تكسيرها في ثوانٍ.

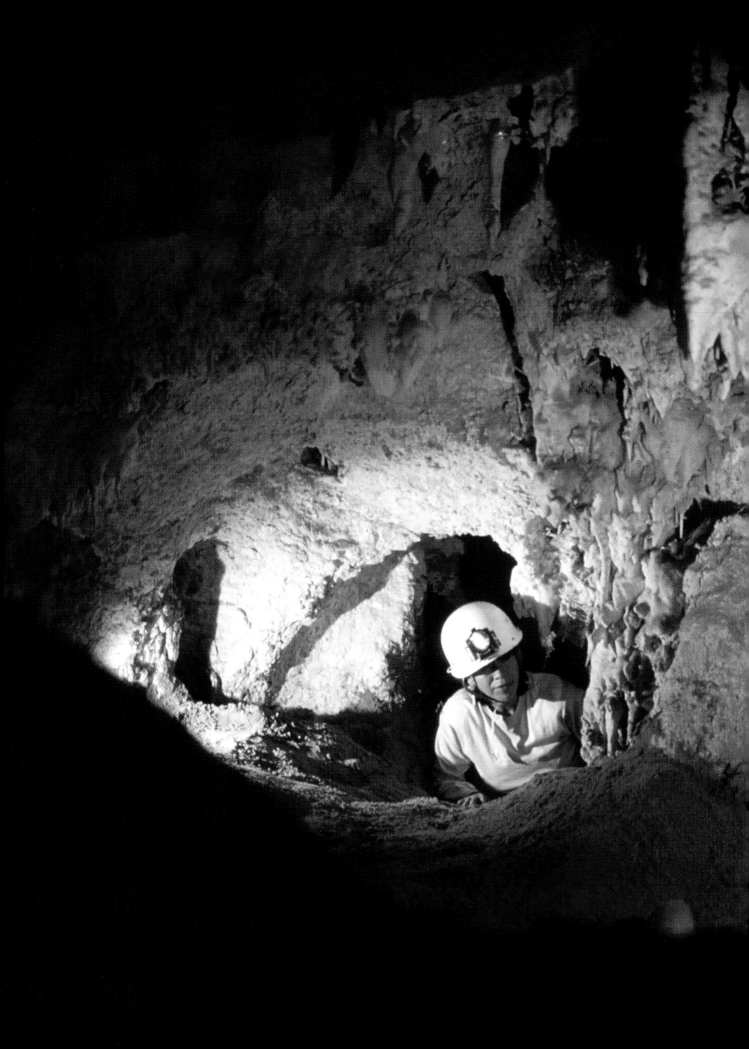

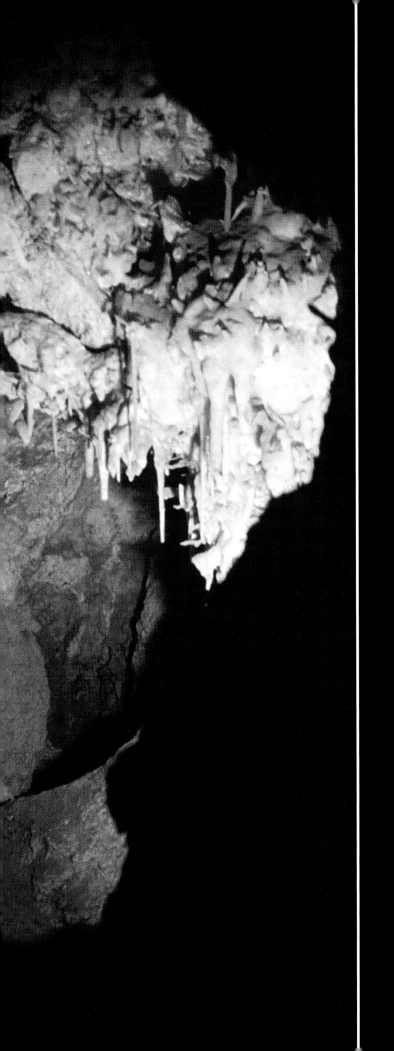

The
Whistling
Teapot

إبريق
الشاي

While drinking tea with friendly bedouins, cave explorers learned about a small hole not far from their tent. The bedouins said a strong current of air was blowing from the hole, a good indicator that the cave could be very large. The entrance turned out to be a tube so narrow that it was impossible to lift the knee in order to climb the cable ladder, forcing explorers to develop a new technique for "auto-extraction" from the hole. Although quite small, the Teapot is one of the most beautifully decorated caves in Saudi Arabia.

المدخل عبارة عن أنبوب ضيق لدرجة أن الشخص لا يتمكن من رفع ركبتيه ليتسلق السلم المعدني مما دفع المستكشفين إلى ابتداع أسلوب جديد (للسحب الآلي) من الحفرة. وعلى الرغم من صغر حجم كهف "إبريق الشاي" إلا أنه يعد واحداً من أجمل الكهوف زخرفة في المملكة العربية السعودية.

Previous page: this cave 'whistles' because of air blowing through a small hole in the wall behind Susy Pint.

Opposite: after passing through the tight entrance tube, the climber dangles from a narrow cable ladder in a large, conical chamber.

الصفحة السابقة: يطلق هذا الكهف صفيراً بسبب الهواء الذي يهب عبر فتحة صغيرة في الجدار خلف سوزي بنت.

الصفحة المقابلة: بعد المرور عبر أنبوب المدخل الضيق ، يكون المتسلق معلقاً من سلم معدني ضيق داخل غرفة كبيرة مخروطية الشكل.

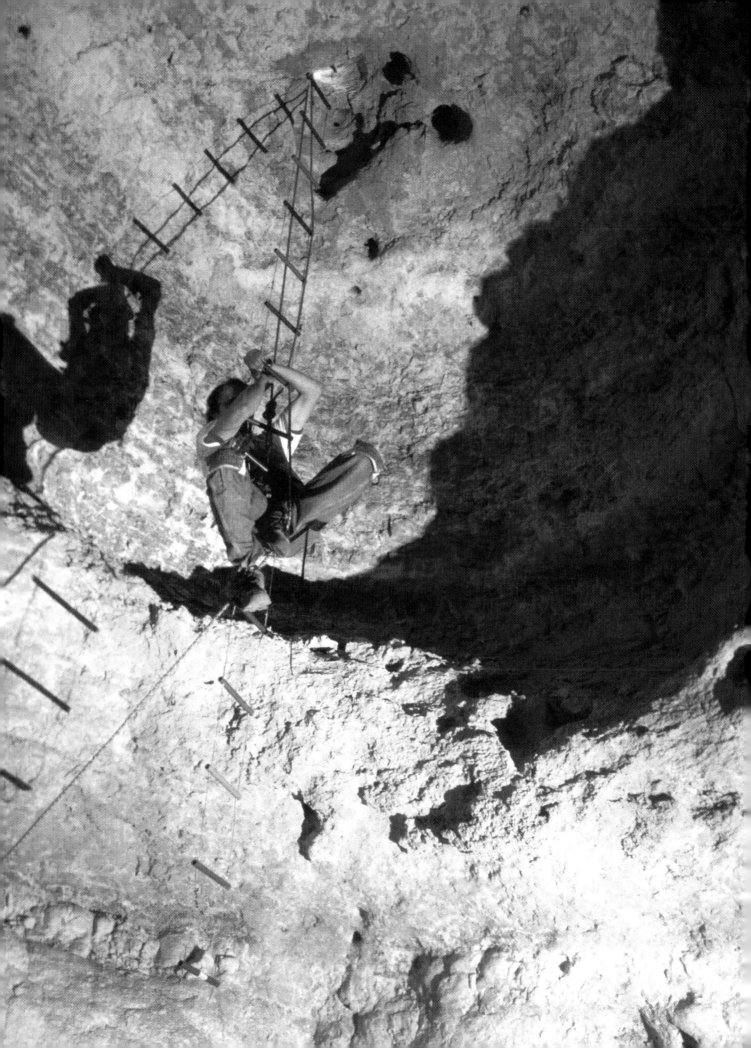

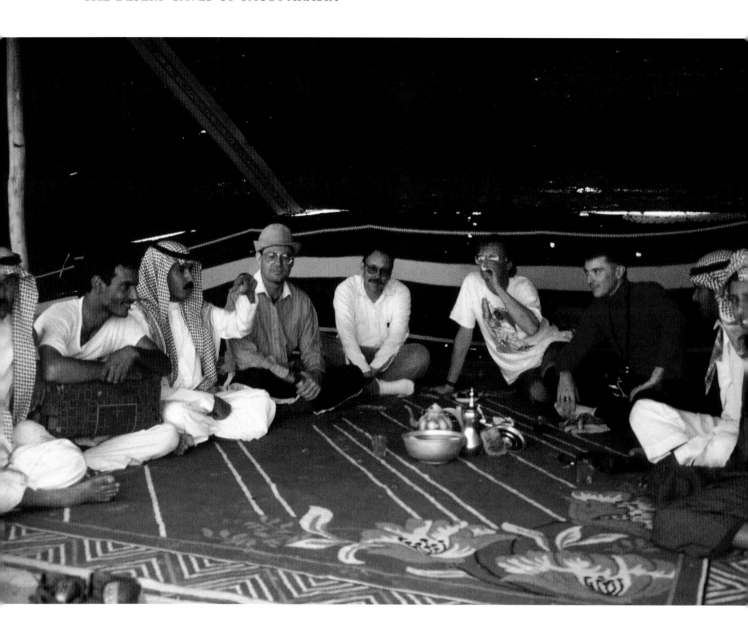

Above: a cup of tea shared with these local people led to the first exploration of the fascinating cave not far from their tent.

Opposite top: the entrance to Teapot Cave. The first explorers only managed to exit with the help of their strong guides.

Opposite bottom: using a rock as a shovel, the explorers patiently dug their way under the cave wall.

أعلى:خلال تناول الشاي مع أهالي المنطقة، تم لأول مرة استكشاف كهف رائع لا يبعد كثيراً عن خيامهم.

أعلى الصفحة المقابلة: مدخل كهف إبريق الشاي. تمكن المستكشفون الأوائل من الخروج بصعوبة بمساعدة دليلهم القوي البنية.

أسفل الصفحة المقابلة: استخدم المستكشفون صخرة كجاروف لحفر ممر تحت جدار الكهف.

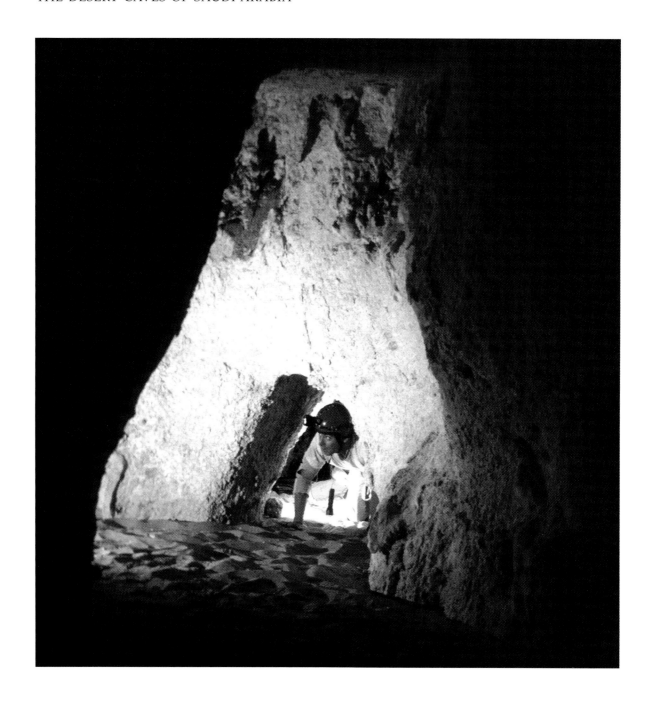

Above: a triangular opening at one end of the entrance room leads to a low passage with smooth, white walls and a soft floor of red sand.

Opposite: exploration of the cave ended at 'the Closet of the Jinn', but air blowing from small holes indicates that more passages lie beyond.

أعلى: فتحة مثلثة الشكل عند أحد طرفي غرفة المدخل وتؤدي الى ممر منخفض له جدران بيضاء ناعمة وأرضية رخوة من الرمل الأحمر.

الصفحة المقابلة: انتهى استكشاف الكهف عند (حجرة الجن) إلا أن الهواء الذي يهب من فتحات صغيرة يدل على وجود مزيد من الممرات بعد تلك البقعة.

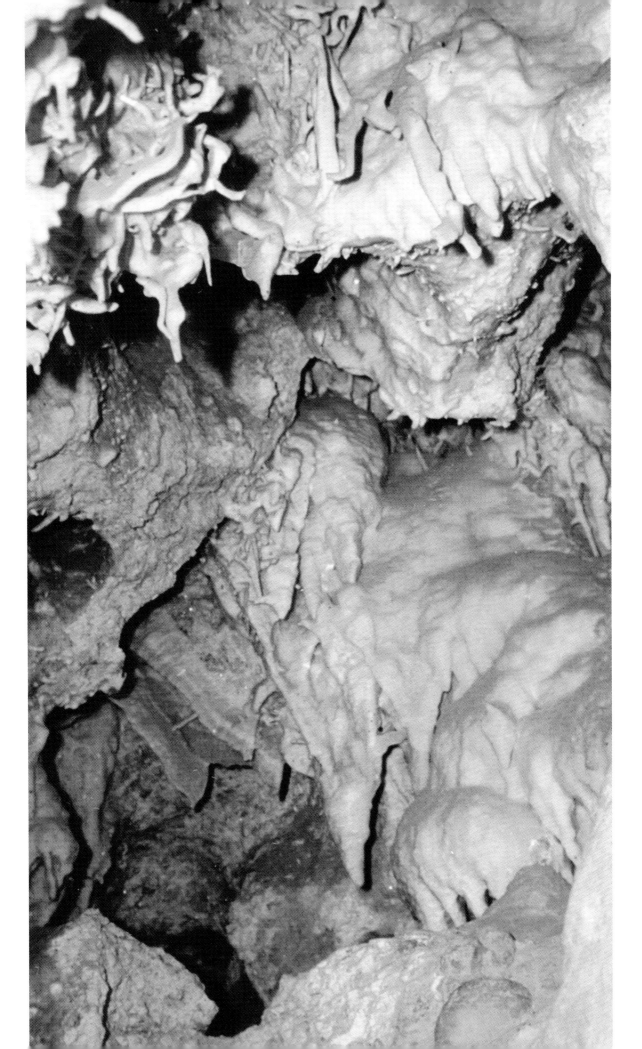

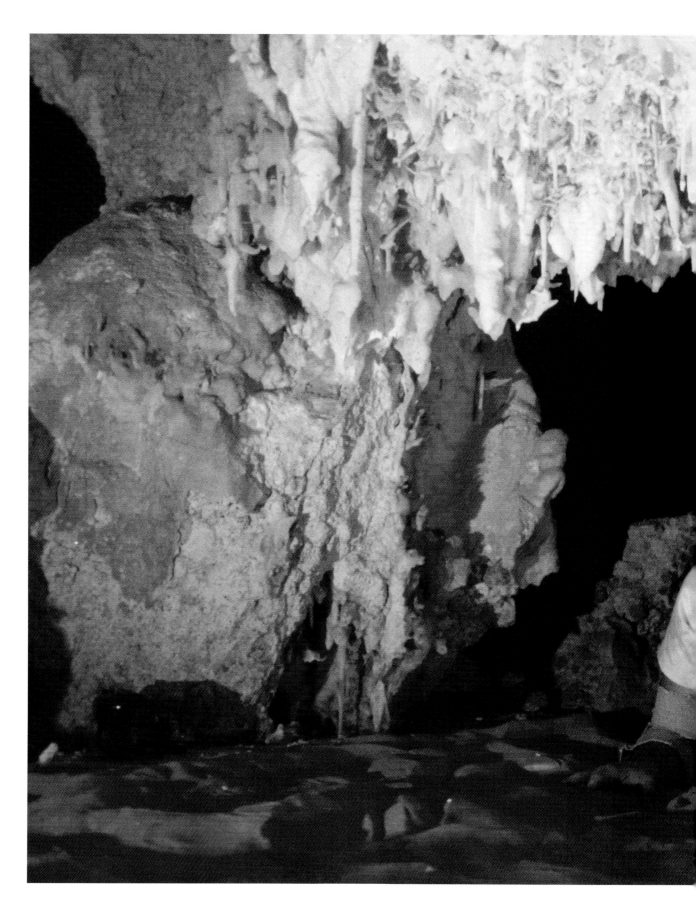

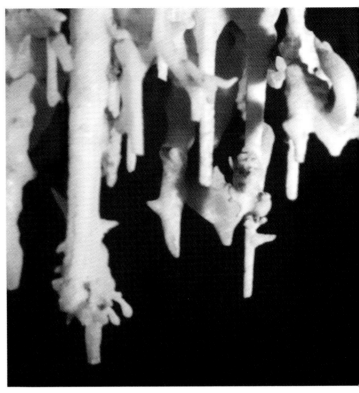

The delicate formations of the Whistling Teapot cave will only be preserved if visitors are careful not to touch them.

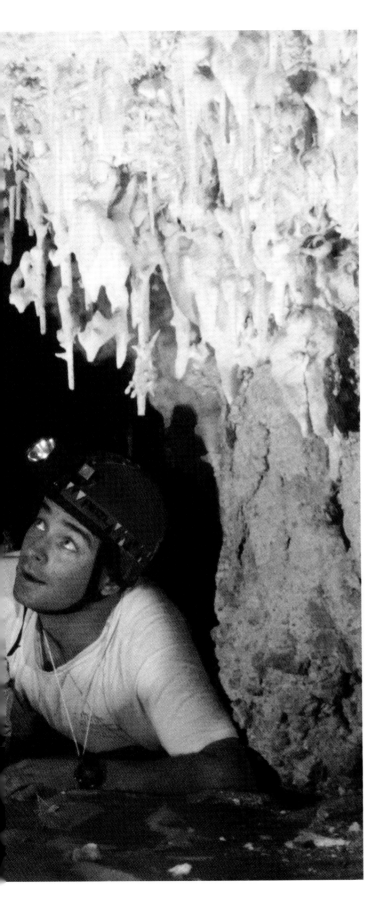

إن الاحتفاظ بالمتكونات الناعمة داخل كهف إبريق الشاي الصافر ، يستدعي عناية خاصة من الزوار بعدم لمس تلك المتكونات.

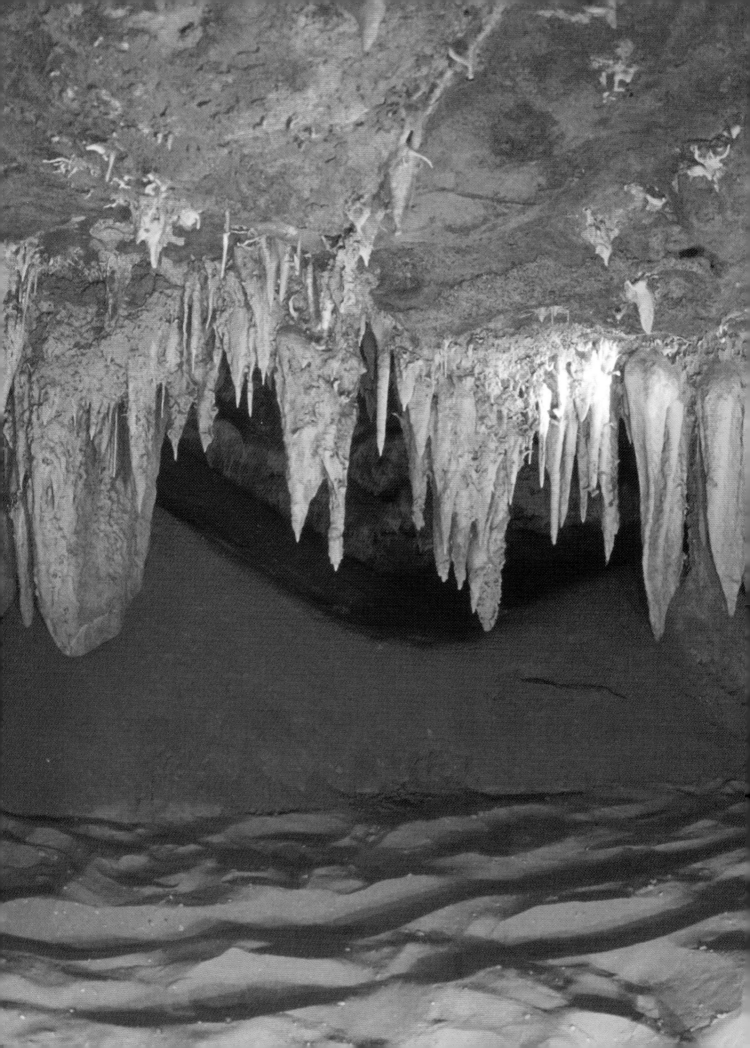

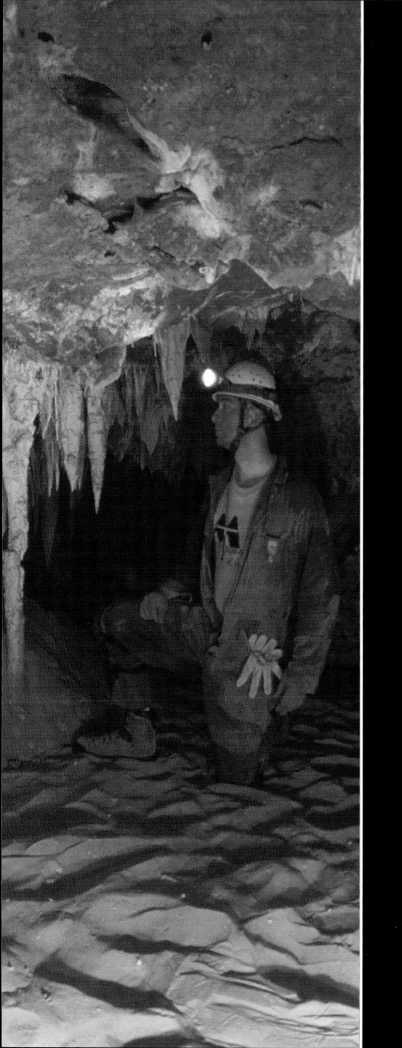

Friendly
Cave

الكهف
الأنيس

A drop of eleven and a half metres leads to a series of rooms that cavers call "friendly" because no crawling is required to visit them and the sandy floor is relatively unencumbered. In this cave, the best decorations are all found in one room where photographer Lars Bjurström felt "very humble, almost like being in a sacred place". Mapping of this cave is now in progress and suggests that it may be much longer than previously thought and not quite as friendly.

يؤدّي انخفاض أرضي ـ يقدر بأحد عشر متراً ـ إلى مجموعة من الحجرات أطلق عليها المستكشفون اسم (الأنيس) لأن الدخول اليها لا يستدعي الزحف ، كما إن أرضياتها الرملية لم تتعرض للعبث. وأفضل الزخارف ـ داخل هذا الكهف ـ موجودة كلها في غرفة واحدة يقول عنها المصور لارس بجورستروم (لقد شعرت بالتواضع كأنني داخل مكان مقدس) و يجري الآن رسم خرائط هذا الكهف الذي يبدو أنه أطول مما كان يعتقد سابقاً وربما لم يعد أنيساً.

Previous page: strategic placement of lanterns brings a warm glow to the Show Room in Friendly Cave.

Opposite: geologist Mahmoud Alshanti pauses during a survey of the cave to admire a formation. Cave maps are important for scientific studies and possible rescue work.

الصفحة السابقة: وضع المصابيح في مواقع استراتيجية يؤمن إضاءة دافئة لغرفة العرض في الكهف الأنيس.

الصفحة المقابلة: الجيولوجي محمود الشنطي أثناء القيام بمسح الكهف وهو يتأمل جمال المتكونات. وتعتبر الخرائط الكهفية هامة للدراسات العلمية وأعمال الإنقاذ المحتملة.

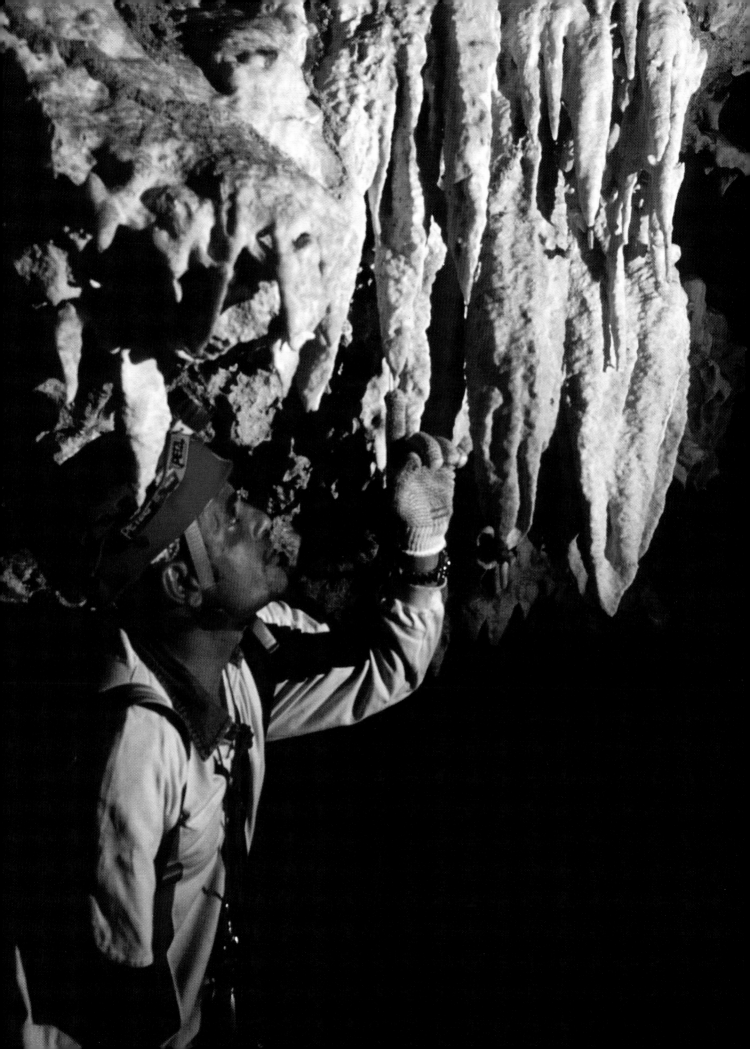

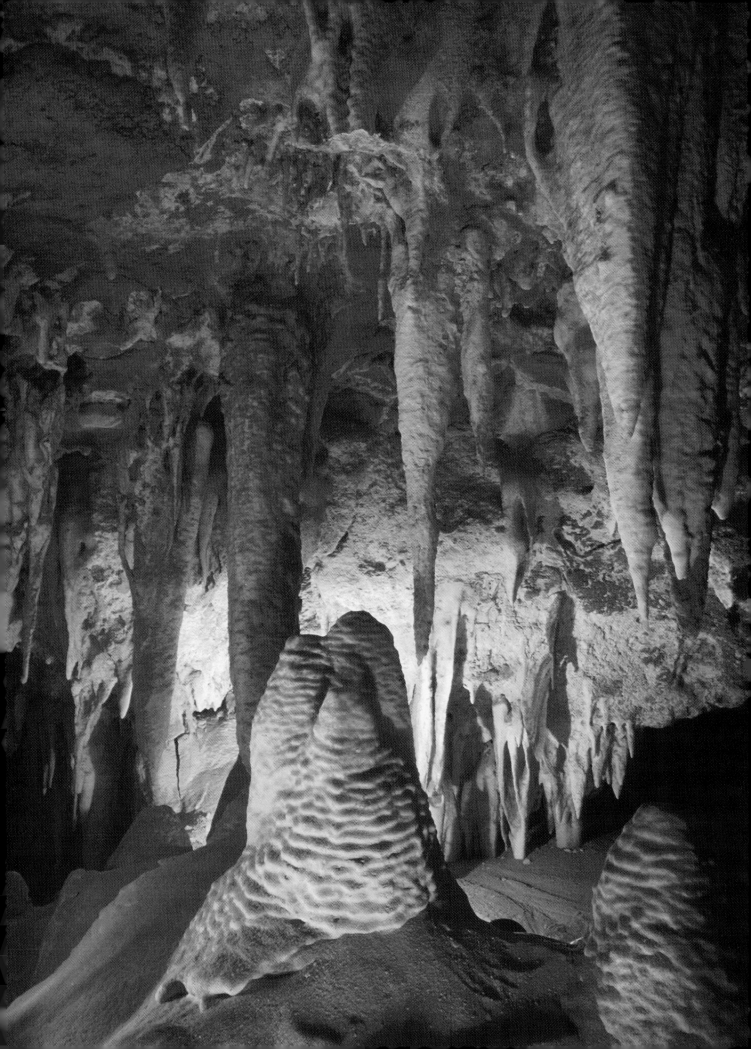

Above: finding a spider in a cave is often a sign that you are not far from an entrance.

Left and below: a stalagmite is formed by drops of water containing calcium carbonate. The process can take hundreds of thousands of years. Photographer Lars Bjurström's arrangements of lamps may result in Friendly Cave's transformation into a tourist cave.

أعلى: إن وجود عنكبوت داخل أي كهف، قد يعني أحياناً أنك لاتبعد كثيراً عن مدخل ذلك الكهف.

يسار وأسفل: تتكون الصواعد (رواسب كلسية) بواسطة قطرات الماء المحتوية على كربونات الكالسيوم، وقد تستغرق هذه العملية مئات ألوف السنين. إن طريقة ترتيب المصابيح بواسطة المصور لارس بجورستروم قد حولت الكهف الأنيس الى كهف سياحي.

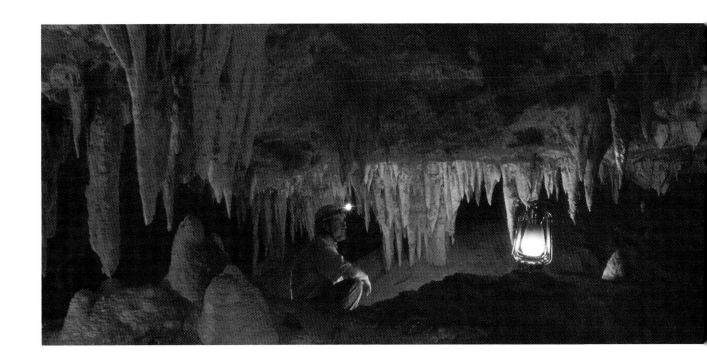

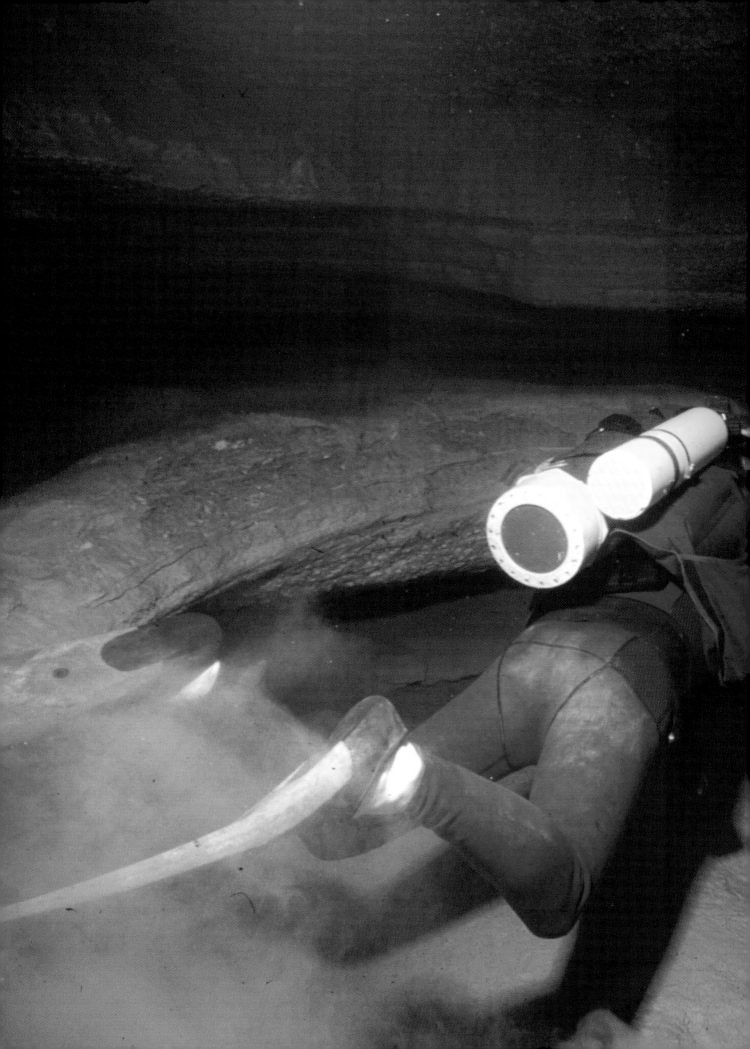

Ain Hit: Diving in the Desert

عيـن هيـت:
الغوص في
الصحراء

Outside Al Kharj lie several sinkholes that offer direct access to a vast aquifer lying deep below the surface. The most famous of these holes is Ain Hit, where geologists, invited on a picnic by King Abdulaziz, discovered the first surface outcrop of anhydrite in the Kingdom. In recent years, experienced cave divers have carried their heavy equipment into Ain Hit, down to the edge of a lake 120 metres below the surface. Using breathing equipment, they have begun an exploration of this dahl's submerged passages, which, they claim, contain the clearest water they have ever seen anywhere in the world.

تقع خارج مدينة الخرج عدة حفر بالوعية تعتبر مدخلاً مباشراً لخزان ماء جوفي شاسع يوجد في العمق تحت السطح. وأشهر هذه الحفر هي "عين هيت" حيث اكتشف الجيولوجيون أول اكتشاف سطحي لصخر الانهيدريت في المملكة عندما كانوا في نزهة بدعوة من المغفور له الملك عبد العزيز. وخلال السنوات الأخيرة قام عدد من مستكشفي الكهوف من ذوي الخبرة بزيارة عين هيت مع معداتهم الثقيلة، ووصلوا الى حافة بحيرة تقع على مسافة ١٢٠ متراً تحت السطح. وباستخدام أجهزة التنفس قاموا باستكشاف الممرات المغمورة بالمياه لهذا الدحل والتي تحتوي ـ حسب رأيهم ـ على المياه الأكثر صفاءً مما شاهدوه في أي بقعة من العالم.

Previous page: the water in Ain Hit is crystal clear, but the flip of a fin can raise the fine anhydrite silt, reducing visibility to zero.

الصفحة السابقة: يتميز الماء في عين هيت بصفاء البلور، الا أن أية حركة قد تثير تراب الانهيدريت الناعم، وبالتالي تنخفض الرؤية الى درجة الصفر.

Opposite: cavers relaxing after a dive in Ain Hit.

الصفحة المقابلة: مستكشفو الكهوف يأخذون قسطاً من الراحة بعد الغوص في عين هيت.

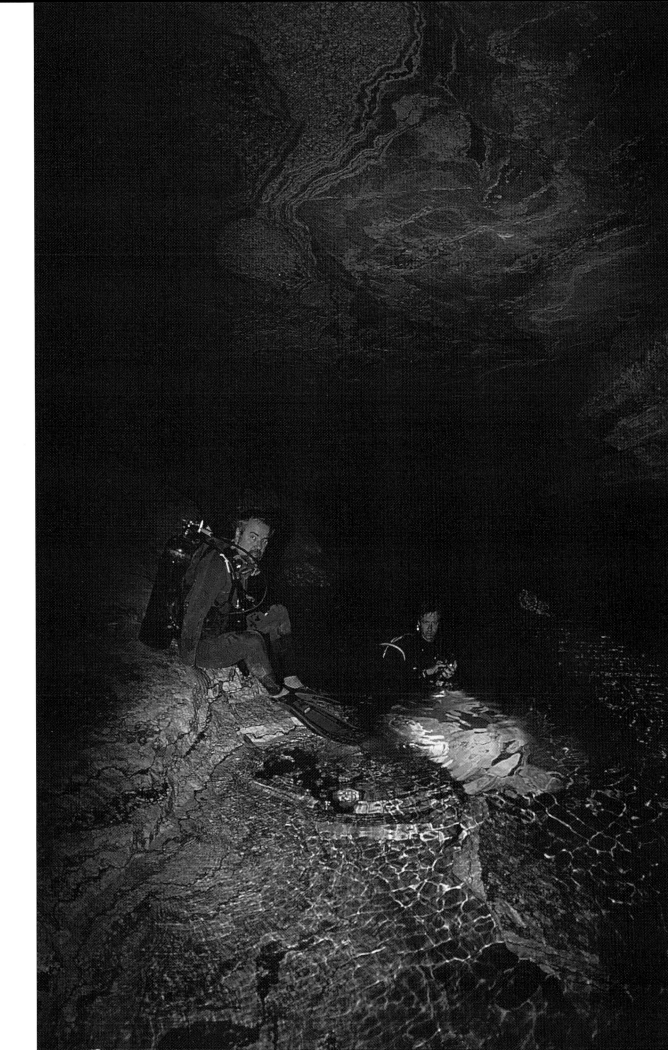

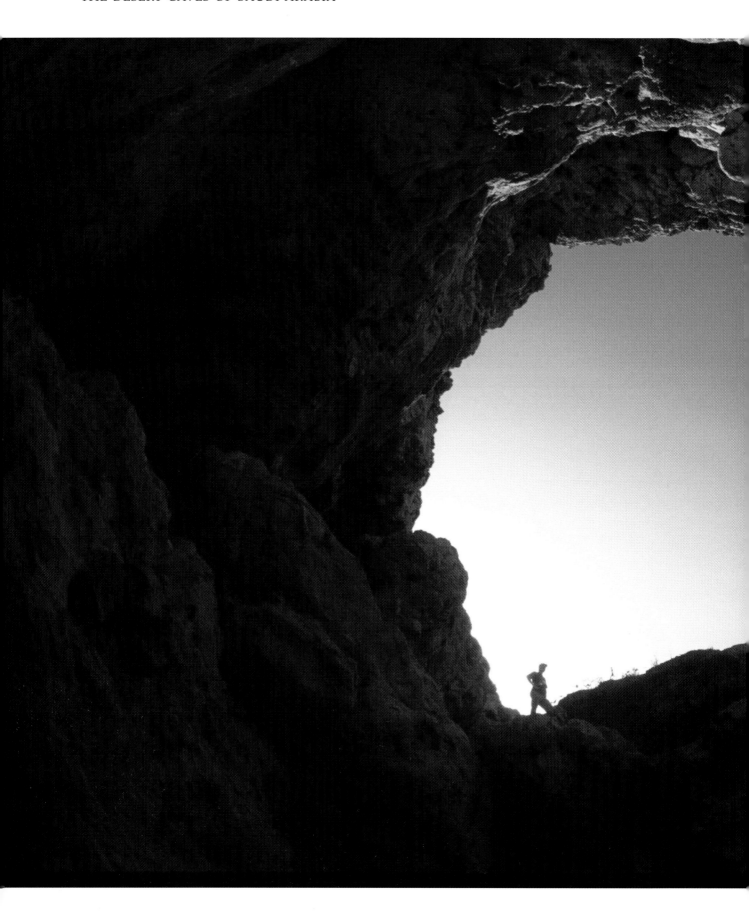

The entrance to Ain Hit, seen from part way down the long steep slope that leads to the water table.

مدخل عين هيت عند مشاهدته من أسفل المنحدر الطويل الذي يؤدي الى منسوب المياه الجوفية.

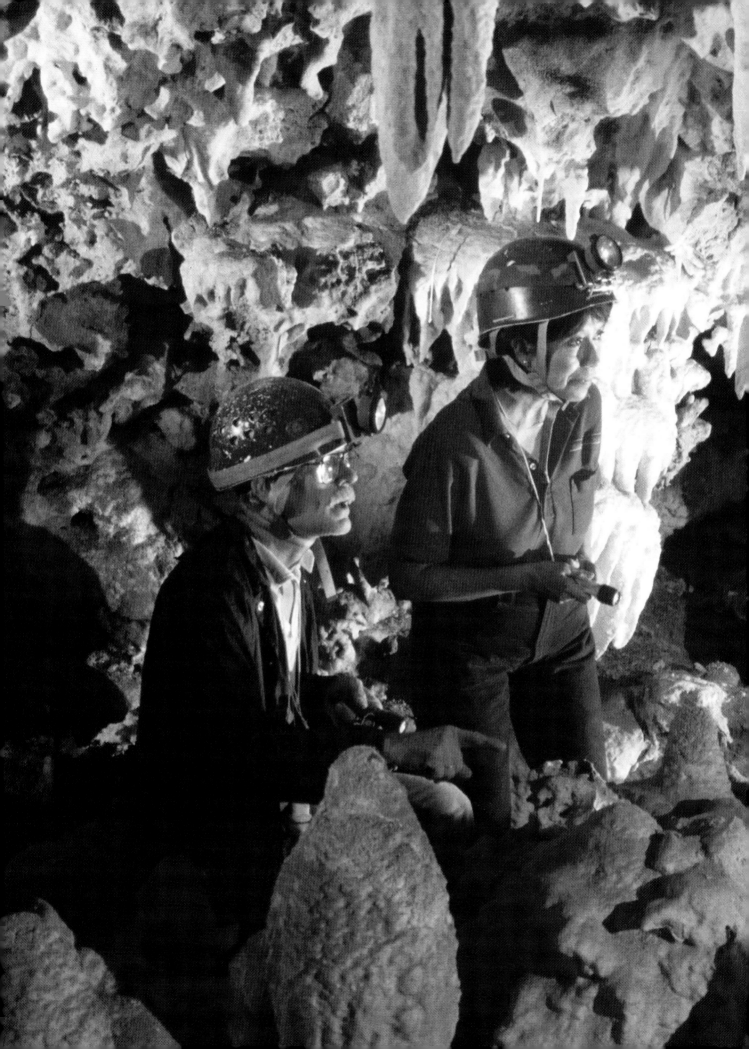

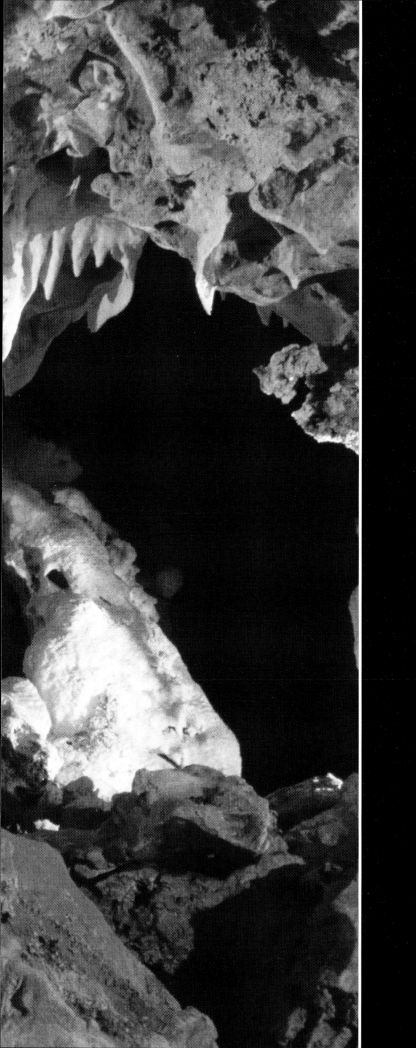

Surprise Cave

كهف
المفاجأة

Hundreds of dahls dot the karst lying east of the Dahna desert. Most of these are small and uninspiring, but among them may be found the entrances to complex caverns of great beauty. Having spent all day checking dahl after dahl, cave explorers were about to give up when they decided to climb down one last hole. Fifteen metres below, they found thick dust and broken rocks. It looked anything but promising but then they came to a few old-looking stalactites. To their great surprise, this passage led them into one of the biggest and most beautiful caves ever found in Saudi Arabia.

تتناثر مئات الدحول في المنطقة الواقعة شرق صحراء الدهناء ومعظمها صغير ولا يجذب الانتباه، ولكن قد توجد بينها مداخل تؤدي الى مغارات ذات جمال باهر. فبعد قضاء اليوم في التنقل من دحل الى آخر قرر المستكشفون النزول إلى داخل حفرة أخيرة، وعلى مسافة خمسة عشر متراً تحت السطح وجدوا طبقة سميكة من الغبار والصخور المكسرة ولم تكن لتجذب الانتباه لو لم يشاهدوا بعض الهوابط التي تبدو قديمة للناظر إليها. وكانت المفاجأة أن قادهم ذلك الممر الى واحد من أكبر وأجمل الكهوف التي تم اكتشافها في المملكة العربية السعودية.

Previous page: John and Susy Pint at the Dragon's Mouth. These stalactites are still growing and drip all the year round.

Opposite: delicate and beautiful crystals such as these have been broken off and removed from several caves on the Summan Plateau.

الصفحة السابقة: جون و سوزي بنت عند فم التنين، لاتزال هذه الهوابط تنمو ويسقط منها الماء على مدار السنة.

الصحفة المقابلة: بعض البلورات الرقيقة والناعمة مثل هذه تعرضت للتكسر وأزيلت من عدة كهوف في هضبة الصمان.

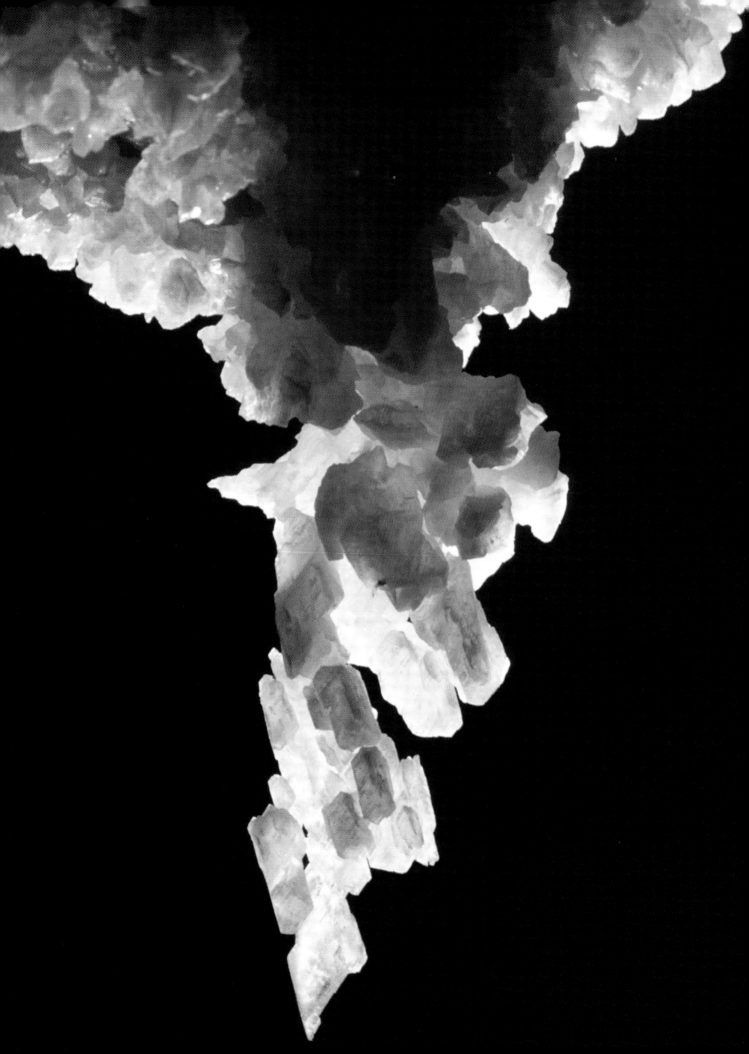

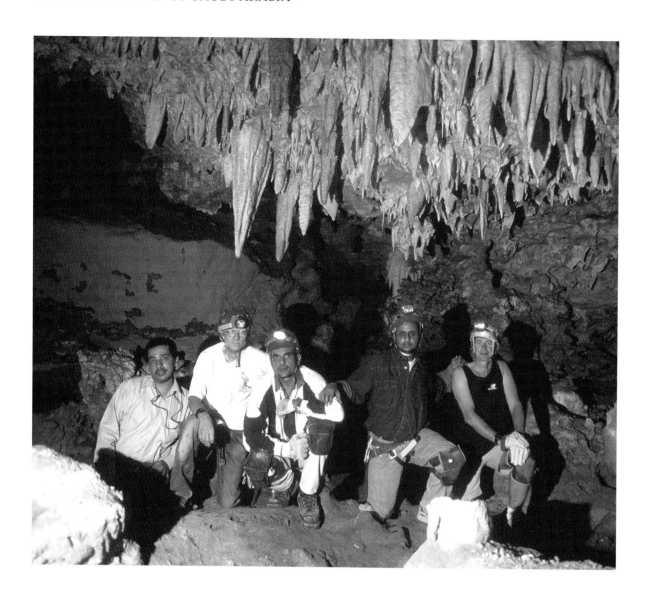

Above: Saudi geologists have been exploring Surprise Cave alongside cavers from many countries, including Sweden, USA, Mexico, Canada and Puerto Rico.

Opposite top: horizontal cracks are noticeable in many formations, possibly the result of an earth tremor long ago.

Opposite bottom: a long crawl along a muddy floor brings Susy Pint to a set of stalactites and stalagmites known as Jaws.

أعلى: الجيولوجيون السعوديون الذين شاركوا في استكشاف كهف المفاجأة مع مجموعة من مستكشفي الكهوف من عدة دول مثل السويد والولايات المتحدة والمكسيك وكندا وبورتوريكو.

أعلى الصفحة المقابلة: يمكن مشاهدة الشقوق الأفقية من العديد من المتكونات التي قد تكون ناتجة عن هزة أرضية وقعت قبل زمن بعيد.

أسفل الصفحة المقابلة: بعدالزحف لمسافة طويلة فوق أرضية موحلة، وصلت سوزي بينت الى مجموعة من الهوابط والصواعد تعرف باسم (الفك المفترس)

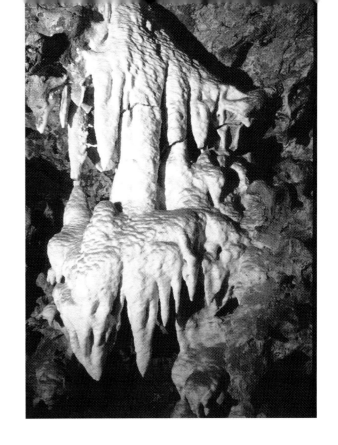

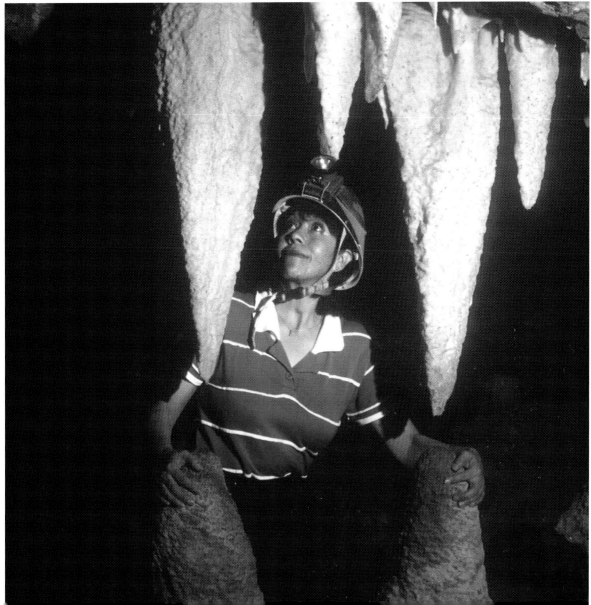

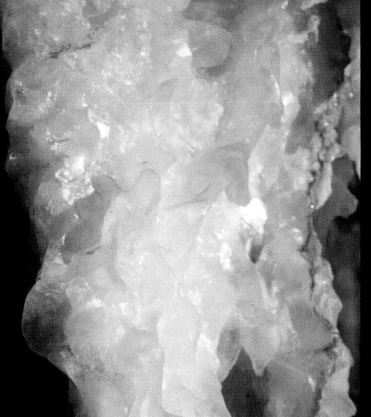

Left: angled 'duck tails' suggest that the coating on the stalactites may have been deposited by supersaturated air.

Opposite (top & bottom right): small nooks and crannies may be filled with long delicate gypsum needles;
(top left) the 'scorpion's tail' is a very delicate segmented formation made of calcite crystals;
(middle right) 'the Chandelier' is an impressive collection of milky white stalactites, each featuring a translucent coating of calcite overlaying an older formation;
(bottom left) some formations are reminiscent of the coral bushes found in the Red Sea.

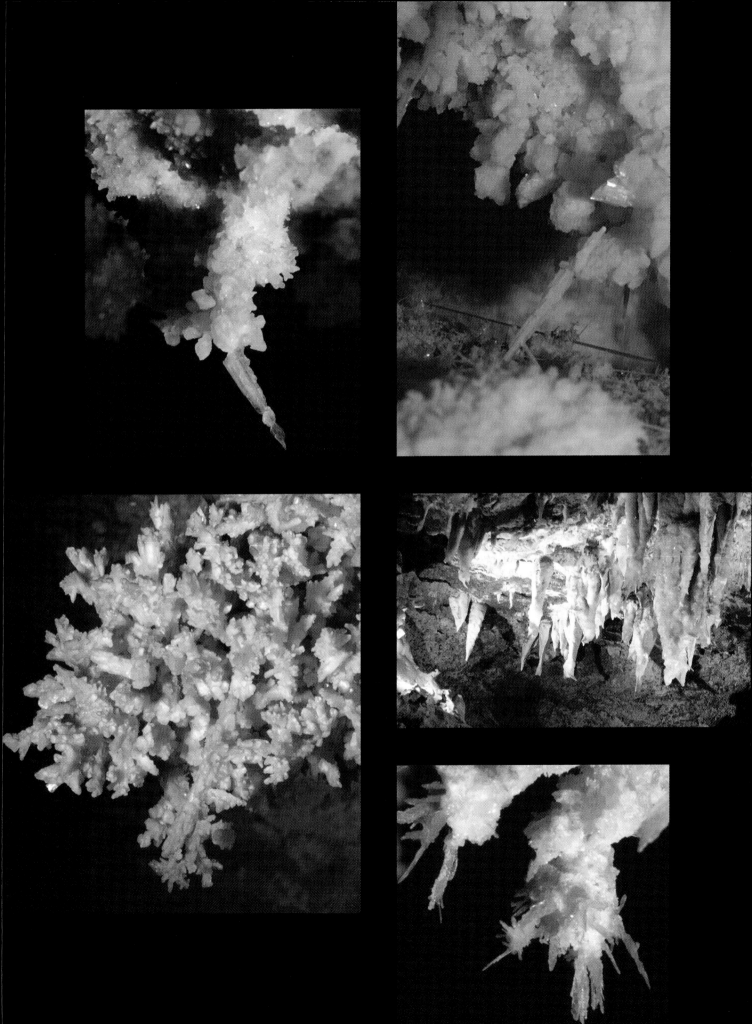

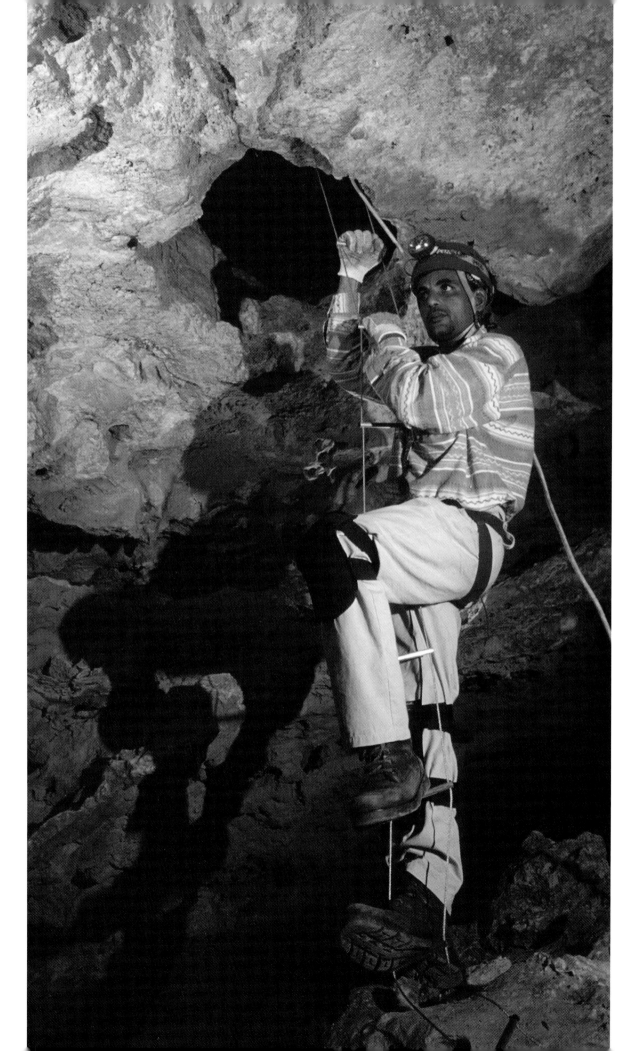

Left: a second entrance to Surprise Cave has recently been discovered. Here we see the basement below the Lizard's Lair.

يسار:مدخل ثانٍ الى كهف المفاجأة تم اكتشافه مؤخراً. ونشاهد هنا صخور القاعدة تحت "عرين السحلية".

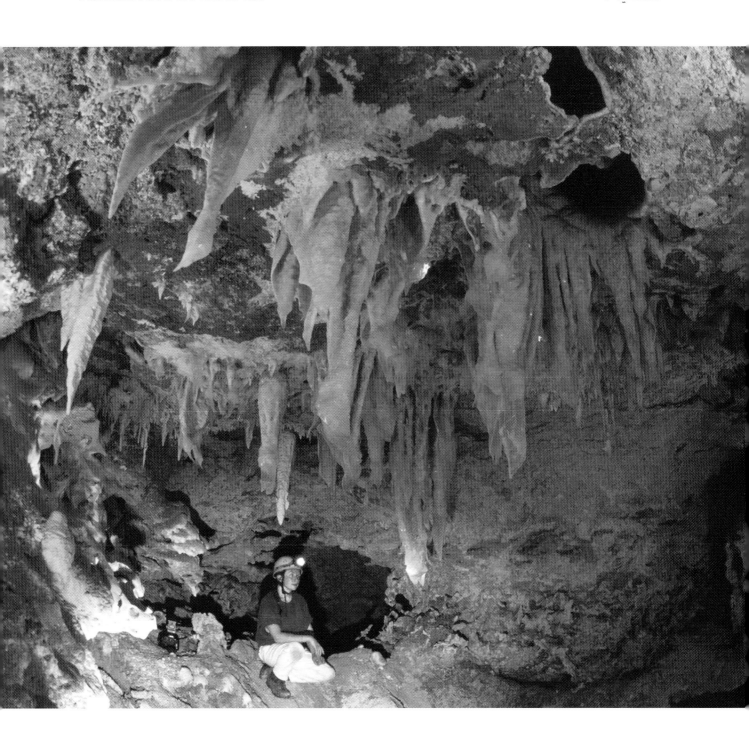

Above: the doorway to passages still unexplored. Approximately 600 metres of tunnels have been mapped in this cave.

أعلى: بوابة الممرات لم يتم اكتشافها بعد، وتم رسم خرائط ٦٠٠ متراً من الأنفاق تقريباً داخل هذا الكهف.

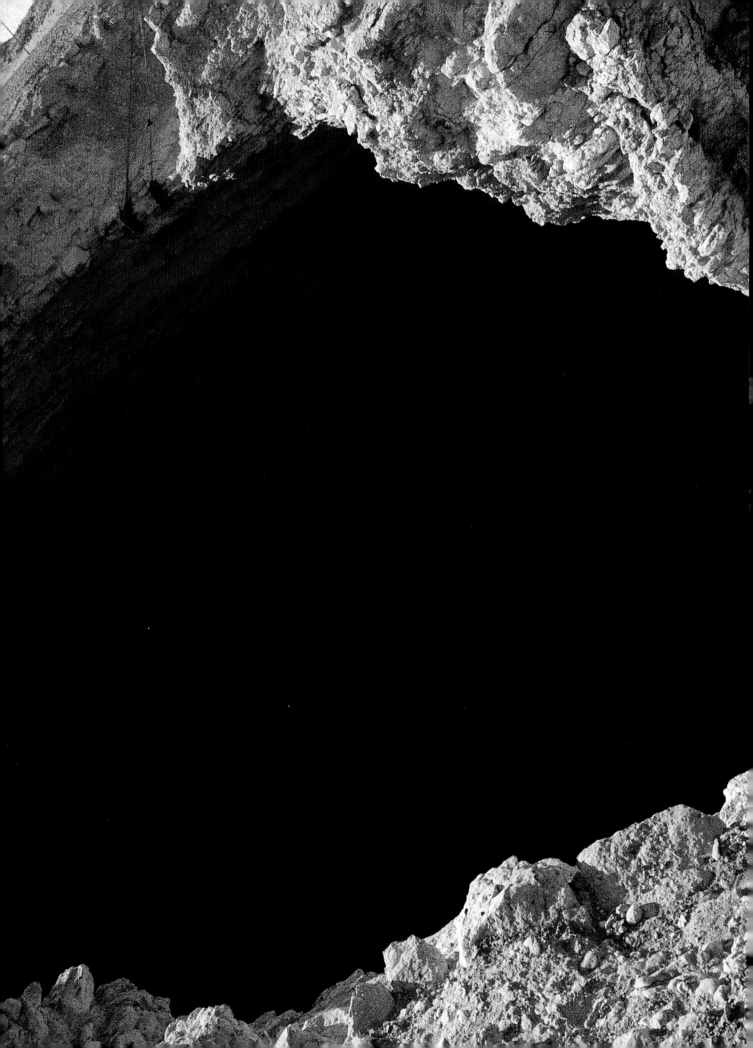

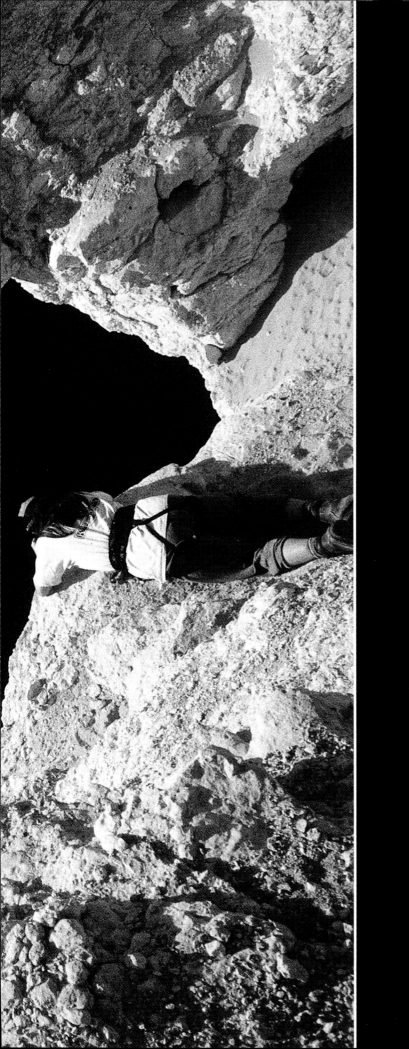

Dahl Abu al Hol

دحل أبو
الهول

In 1999, an Aramco wildcatter was crossing one of Arabia's most desolate deserts. Suddenly he found himself perched at the edge of a huge black maw, its bottom invisible. Realizing how easily this hole could swallow up a speeding vehicle, the wildcatter had a wall of sand and gravel erected around the enormous pit. He mentioned his discovery of this previously unreported chasm to an Aramco writer who, in turn, reported it to the www.Saudicaves.com web site. Thanks to the speed of electronic mail, cave explorers all over the Kingdom were soon planning an expedition to one of the most impressive deep pits in Saudi Arabia.

في عام ١٩٩٩م بينما كان أحد المنقبين العاملين لدى أرامكو يهم بعبور الصحراء، وجد نفسه فجأة أمام حفرة سوداء ضخمة لا أثر لقاعها. وأدرك أن تلك الحفرة يمكن أن تبتلع سيارة مسرعة، فقام ببناء جدار من الرمل والحصى حولها. وقام بإبلاغ احد منسوبي أرامكو بذلك الأمر، وقام الأخير بدوره بنشر الخبر على موقع الهيئة على الانترنت www.saudicaves.com وعلى اثر ذلك تم تعميم الخبر على مستكشفي الكهوف في كافة أرجاء المملكة، وبدأ التخطيط للقيام برحلة استكشافية الى واحدة من أعمق الحفر المثيرة في المملكة.

Previous page: communicating with people at the bottom of the dahl is difficult and requires shouting each word in isolation.

الصفحة السابقة: التخاطب مع الآخرين عند قاع الدحل أمر صعب ويتطلب الصياح لإسماعهم.

Opposite: on the floor of the cave, directly under the entrance, lies a steep hill of sand and rocks, created by the collapse of the roof.

الصفحة المقابلة: على أرضية الكهف وتحت المدخل مباشرة يقع تل منحدر من الرمال والصخور تكوّن بفعل انهيار السقف.

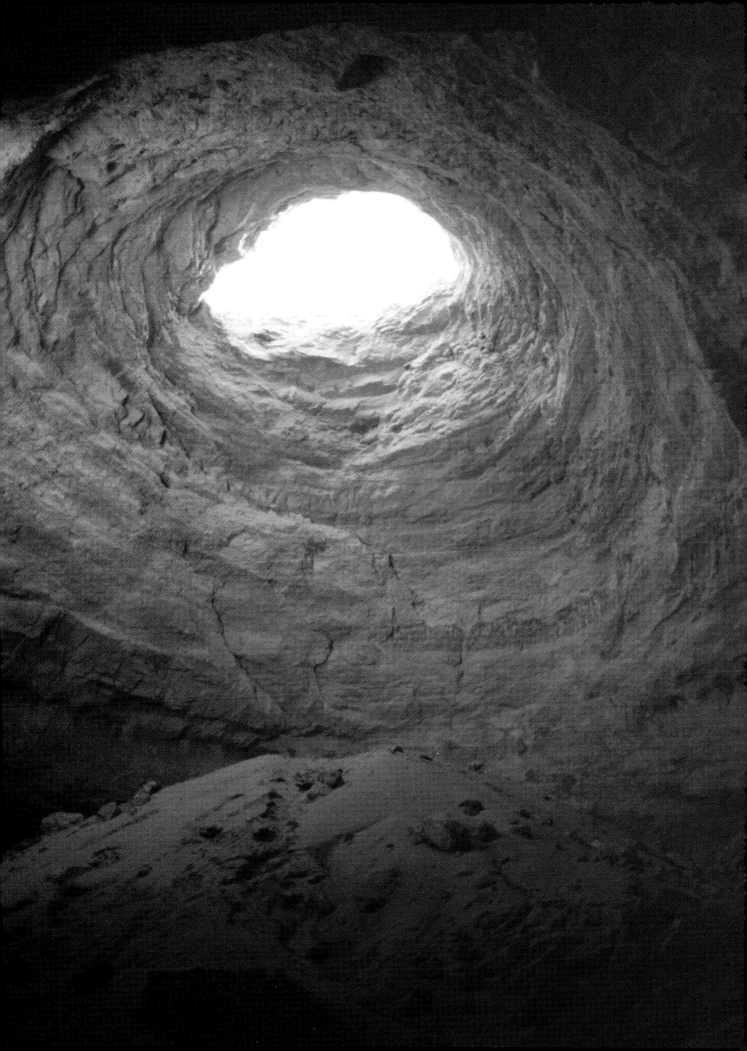

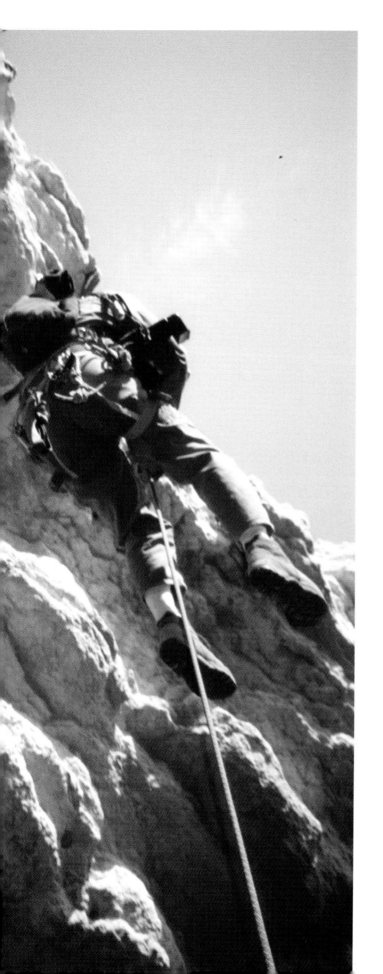

Left and below: with the Single Rope Technique, a caver's life depends on only one rope, which must be well padded wherever it touches the rock, to avoid abrasion.

Opposite top: vertical cave exploration is extremely dangerous and requires extensive training and practice.

Opposite bottom: friction caused by the rope sliding through metal bars allows cavers to control their descent into the deep pit.

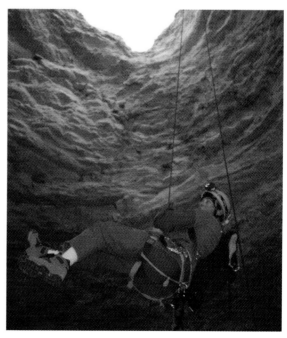

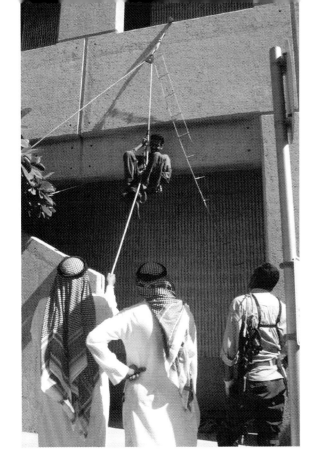

يسار وأسفل: التسلق باستخدام أسلوب الحبل المفرد الذي يجب تأمينه بالحشوات لتفادي حدوث خدوش.

أعلى الصفحة المقابلة: يعتبر استكشاف الكهوف الرأسية أمراً خطيراً للغاية ، ويتطلب كثيراً من التدريب والممارسة.

أسفل الصفحة المقابلة: الاحتكاك الذي يسببه الحبل عند انزلاقه عبر القضبان المعدنية يسمح للمتسلق بالمحافظة على توازنه للنزول إلى داخل الحفرة.

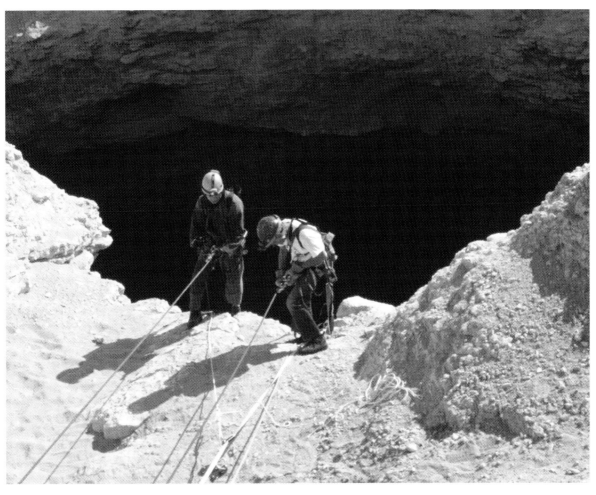

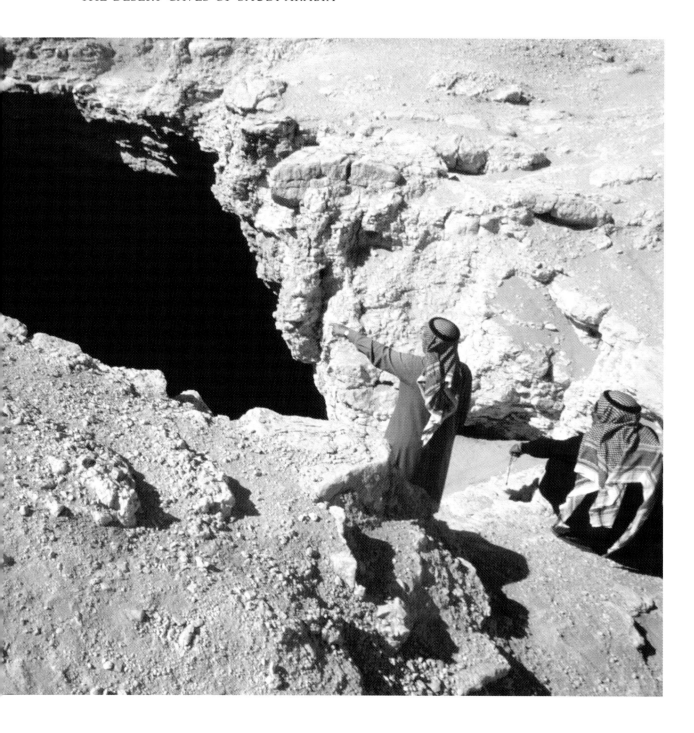

Local people refer to this cavern as Abu al Hol, Father of Fear.

يطلق الأهالي على هذه المغارة اسم "أبو الهول"

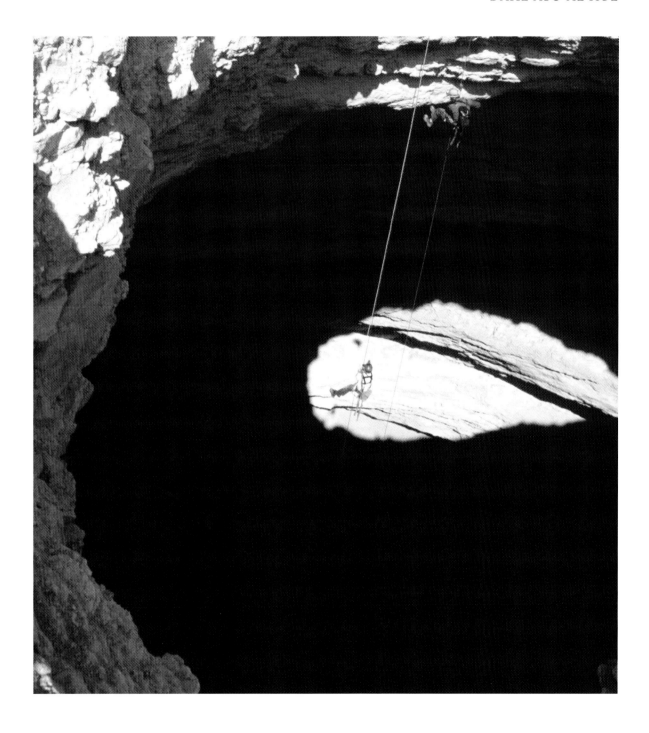

Exploration of Dahl Abu al Hol was made
possible thanks to the assistance of Saudi Aramco
World Magazine.

تم استكشاف دحل ˮأبو الهولˮ بمساعدة مشكورة
من مجلة (عالم ارامكو السعودية).

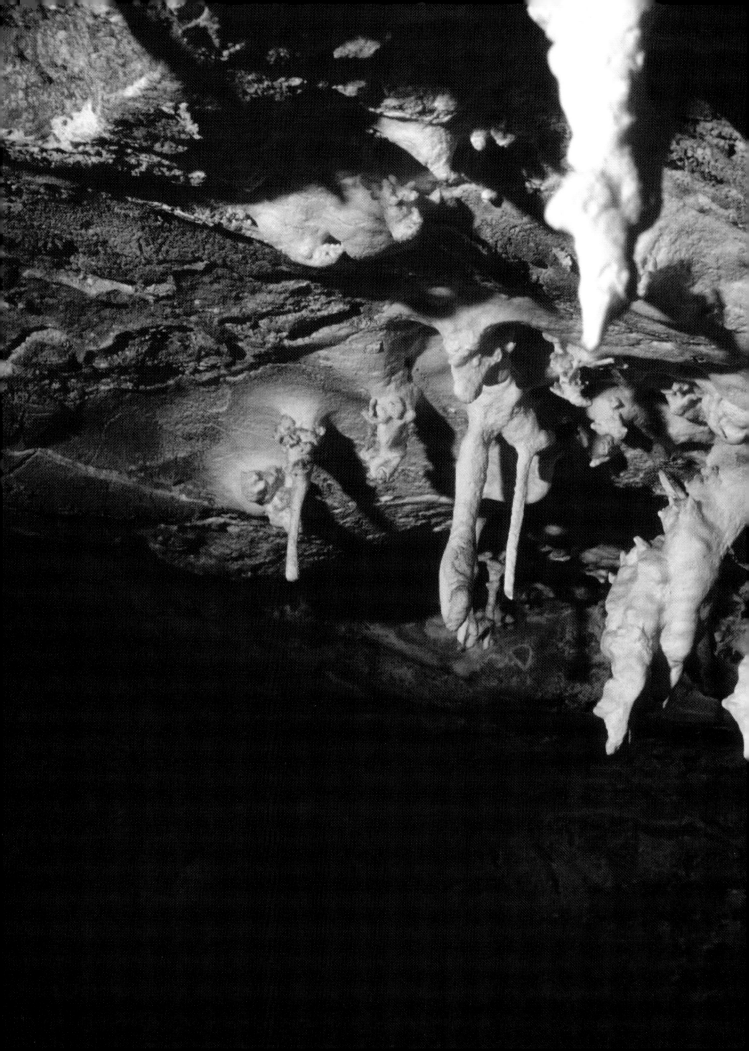

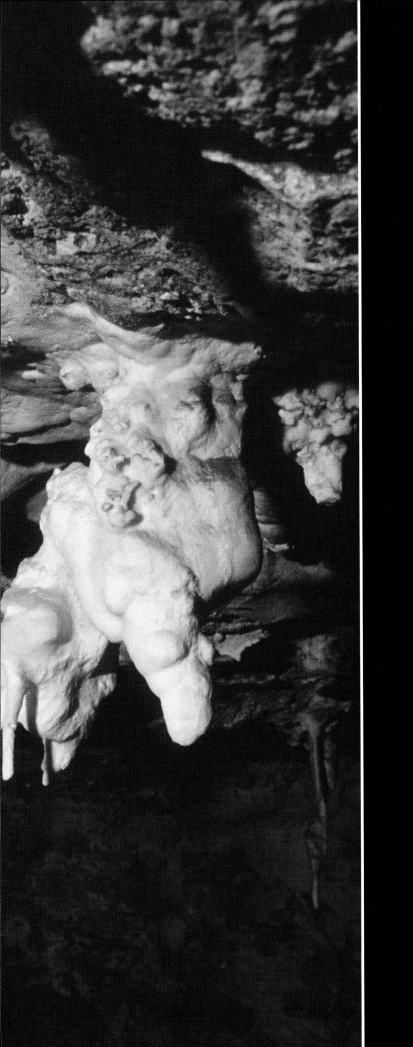

Gecko
Cave

كهف
السحالي

This cave gets its name from the many geckos (Ptyodactylus hasselquistii) that wander about its ceiling. These creatures are very beneficial to human beings because one of their favorite meals is the sand fly, which carries the bacteria that causes leishmaniasis, a disease that has long plagued the inhabitants of the Summan Plateau. Much of Gecko Cave can only be visited on hands and knees, but the thick carpet of sand found throughout the cave makes this a pleasant task. Visitors will find themselves surprised again and again by the beautiful and delicate formations decorating every room.

يستمد هذا الكهف اسمه من العديد من السحالي التي تتجول حول سقفه. وهذه المخلوقات مفيدة للانسان لانها تتغذى على الذباب الرملي الذي يحمل البكتيريا التي تسبب مرض "اللشمانيا" وهو مرض فتك بالكثير من البدو الذين يقطنون هضبة الصمان. وتستدعي زيارة الكهف الزحف على الأيادي والساقين، وهو أمر غير شاق نظراً للطبيعة الرملية لأرضية الكهف. وسيجد الزائر نفسه مشدوداً الى المتكونات الجميلة الناعمة التي تزخرف كل غرفة.

Previous page: horizontally banded formations are found in several parts of Gecko Cave, but have rarely been seen elsewhere in desert caves.

Opposite: this gecko proved to be the ideal photographer's model, posing patiently for over an hour and even allowing itself to be moved from place to place on the stalactite.

الصحفة السابقة: متكونات شرائطية أفقية في العديد من أجزاء كهف السحلية، ونادراً ما توجد في الكهوف الصحراوية الأخرى.

الصفحة المقابلة: سحلية تتحرك من هابط إلى آخر مما استغرق تصويرها ساعة.

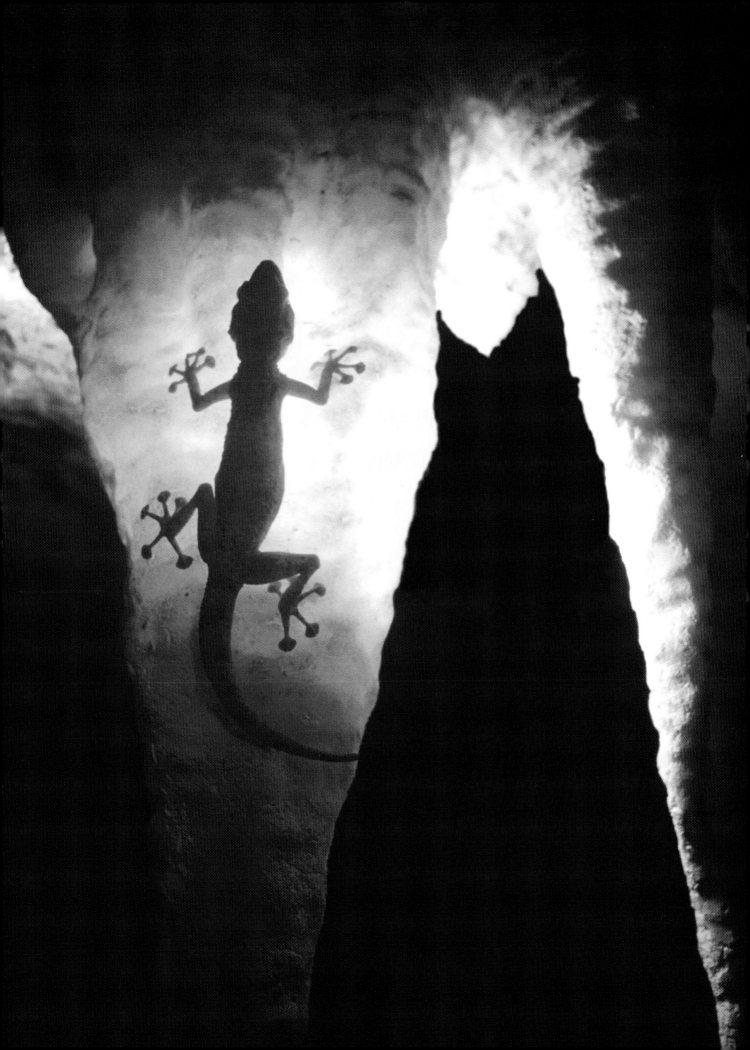

Cavers from three different nations pause for a rest during the first exploration of Gecko Cave, which showed no signs of ever having been visited before.

مستكشفون من ثلاث دول مختلفة، ينالون قسطاً من الراحة أثناء استكشاف كهف السحلية الذي يبدو انه لم يقم أحد بزيارته من قبل.

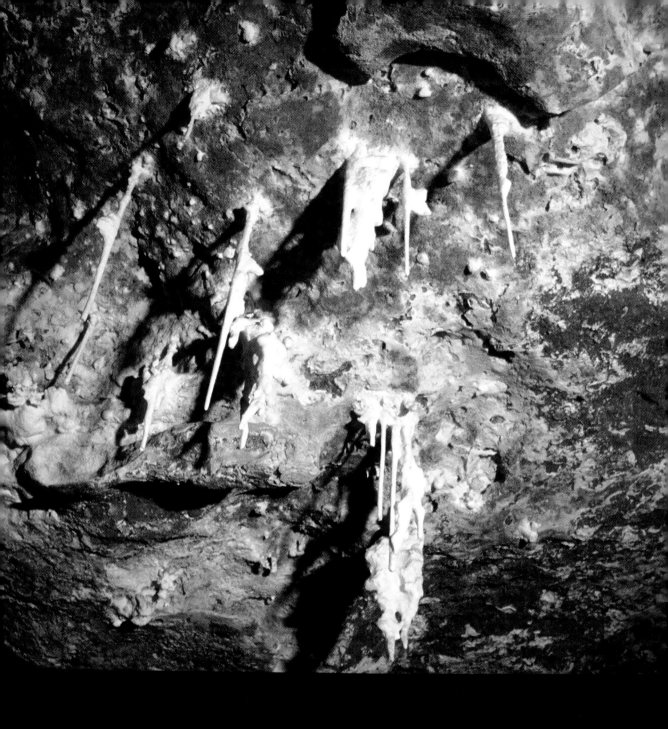

A crawling-caver's-eye view of the cave's multicoloured ceiling and soda-straw stalactites. It will take more than a gecko guard to protect the formations of this cave, all of which hang from low ceilings and are easy to bump into.

سقف الكهف (متعدد الألوان) و هوابط على شكل مصاصات الصودا كما يبدو من خلال عين مستكشف يزحف داخل الكهف. إن حماية المتكونات الجميلة داخل هذا الكهف (والتي تتدلى من سقوف منخفضة)

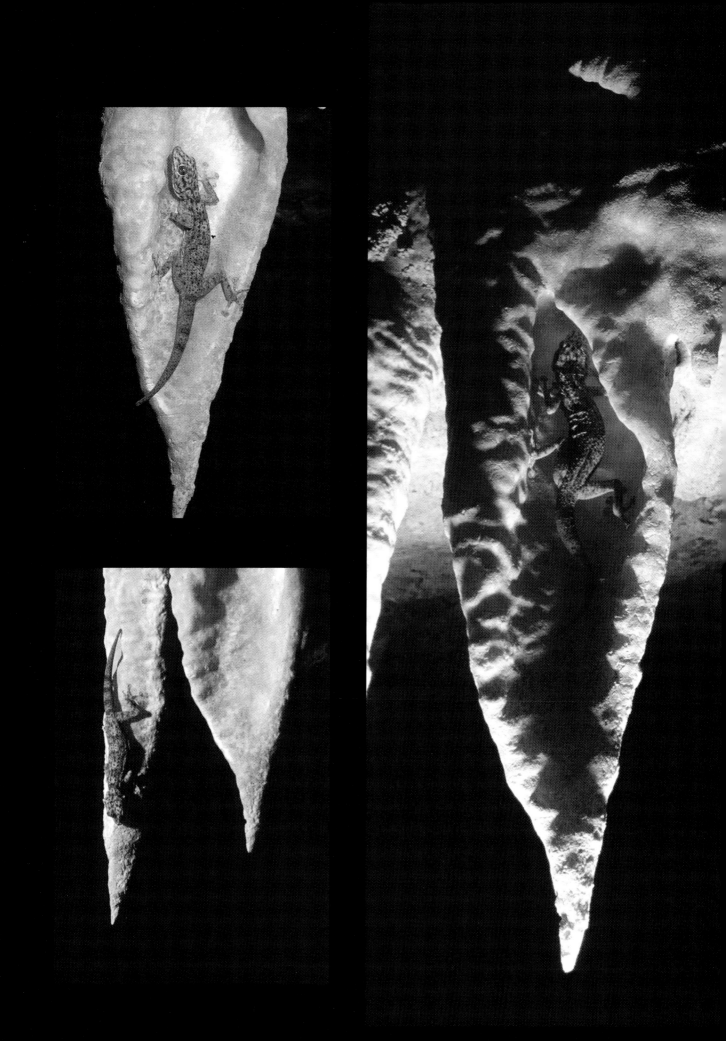

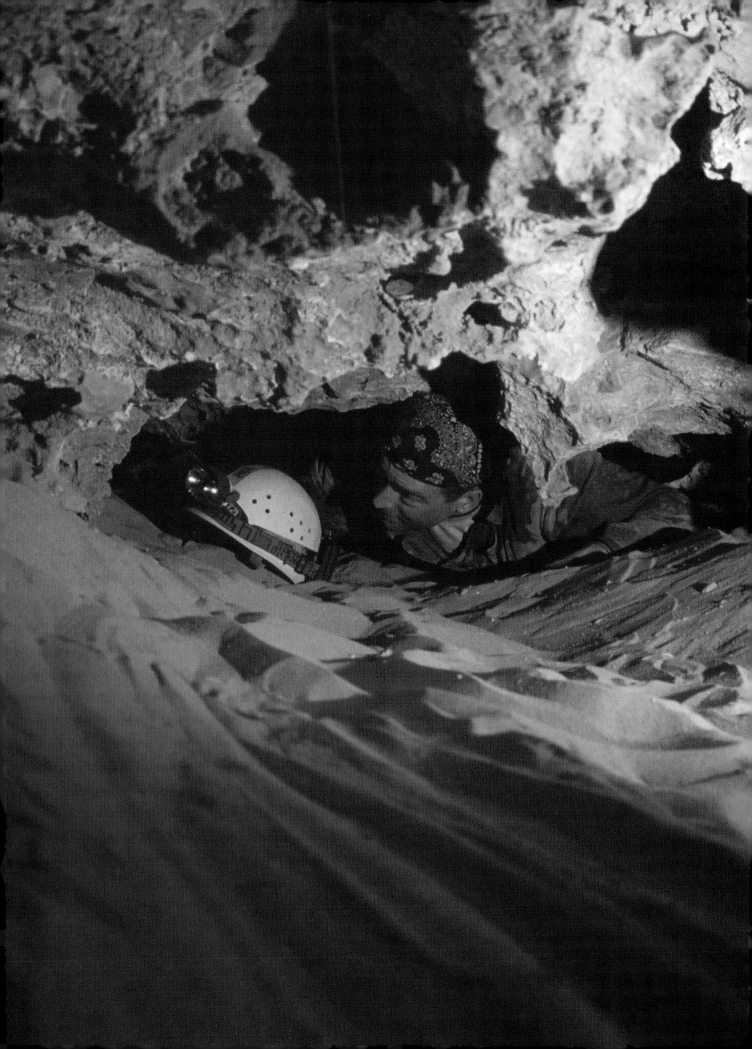

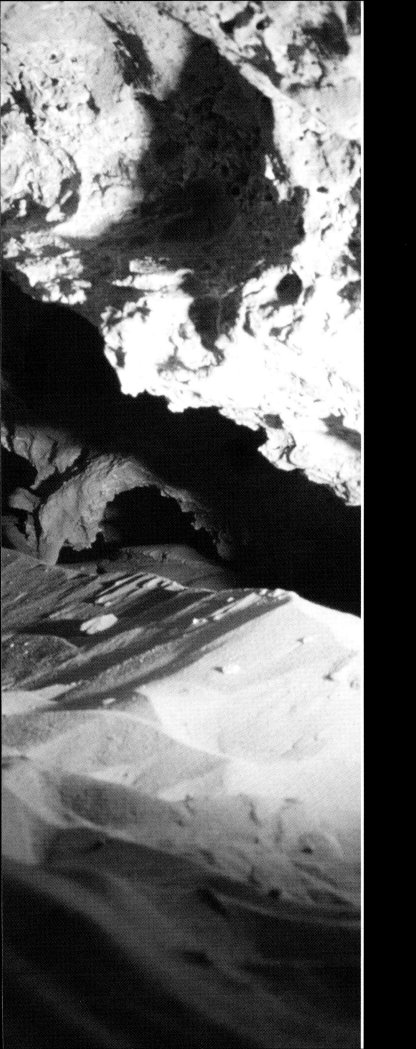

Many, Many Dahls

لعديد من
الدحول

When the Emir of Ma'aqala welcomed cave explorers to his region in the early 1980s, he appointed as their guide an old and experienced local man named Sultan. Everywhere he took his visitors, Sultan repeated the same words, "Wajid duhul hinna, wajid!" (There are many dahls around here, many!) A number of these dahls, not included in the previous chapters, are quite interesting or beautiful. Some display deeply worn grooves indicating they were used as water wells over long periods of time. Others are home to bats, foxes, rock doves, monitor lizards and even palm trees.

عندما قام مستكشفو الكهوف بزيارة أمير قرية المعاقلة في أوائل الثمانينات الميلادية، كلف الأمير دليلاً محلياً خبيراً بالمنطقة يدعى سلطان ليصطحبهم في جولاتهم. وكان سلطان يردد أن العديد من الدحول توجد في هذه المنطقة. وبعض هذه الدحول (التي لم يتم إدراجها إلى الفصول السابقة من هذا الكتاب) جميلة ومثيرة للغاية. وقد تم استخدام بعضها كآبار مياه في السابق لفترات طويلة، والبعض الآخر يعتبر موطناً للخفافيش والثعالب والحمام والسحالي، وحتى بعض اشجار النخيل.

Previous page: a tight crawl in Dog Cave. For caver Mike Gibson, 'tight' means he has to remove his helmet to get through the hole.

الصفحة السابقة: الزحف الى داخل "كهف الكلب" كان على مايك جبسون أن ينزع خوذته للمرور عبر الفتحة.

Right: a thick, truncated column pierces the main chamber of the tiny Thousand Wings Cave.

اليمين: عمود سميك مقطوع يخترق الغرفة الرئيسية في كهف الألف جناح.

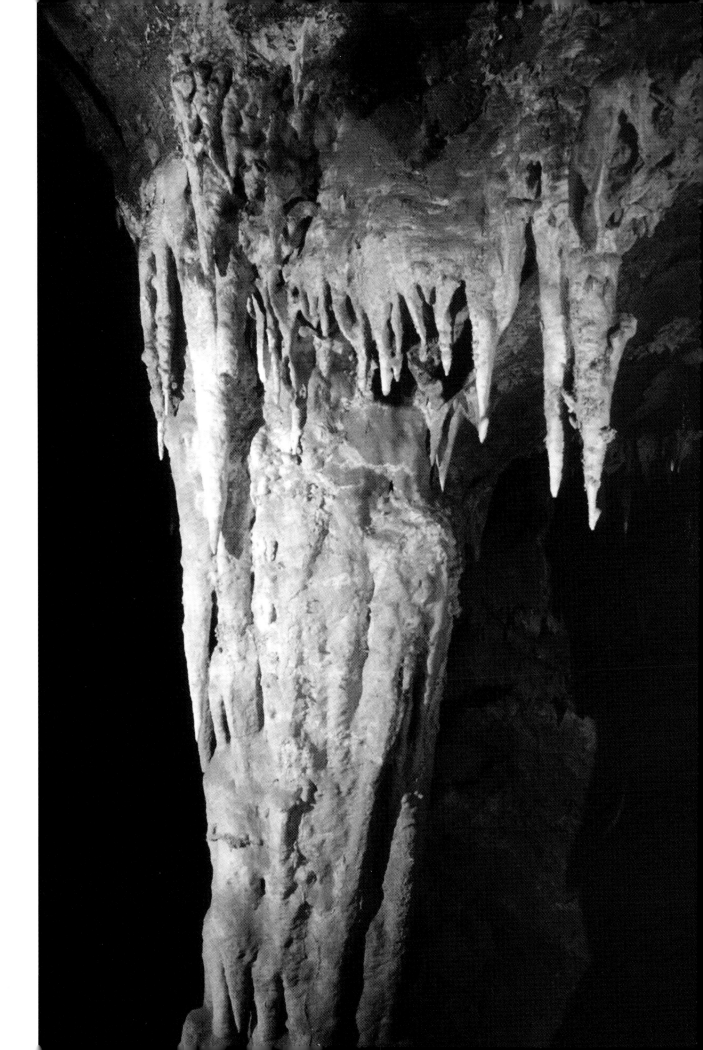

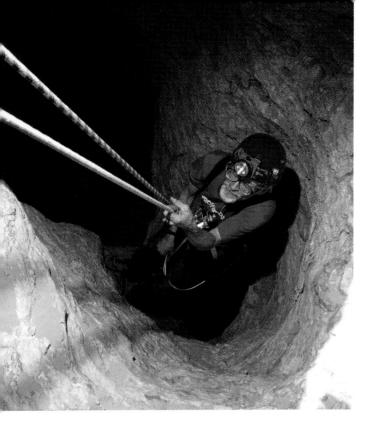

Top left: cavers have popped in and out of hundreds of holes like this one, often only to find nothing at the bottom but rocks and sand.

Bottom left: biologist Dave Peters, 'tallest caver in Arabia'.

Right: Dahl Abu Jirfan has only one room, which is filled from end to end with a healthy growth of trees.

Below: helpful hands hold a caver attempting to extract a rock blocking the entrance for Dahl Iftakh.

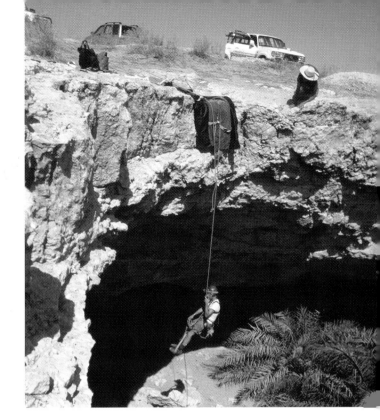

أعلى اليسار: تجول المستكشفون في مئات الحفر مثل هذه، دون أن يجدوا شيئاً في قيعانها غير الرمل و الصخور.

أسفل اليسار: عالم الأحياء ديف بيترز (أطول مستكشف كهوف في المملكة)

يمين: يحتوي دحل "أبو جرفان" على غرفة واحدة مملوءة من طرف لآخر بأشجار نامية نمواً جيداً.

أسفل: يتلقى أحد المستكشفين المساعدة لاستخراج صخرة تسد مدخل دحل "إفتح".

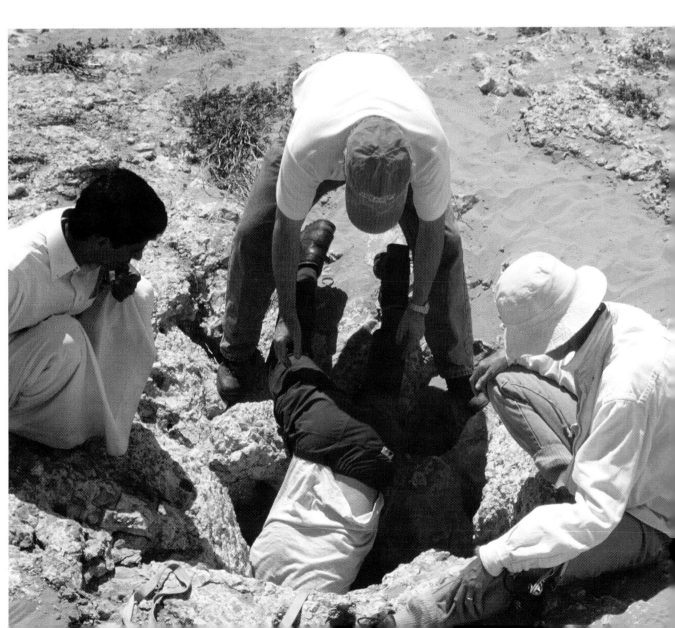

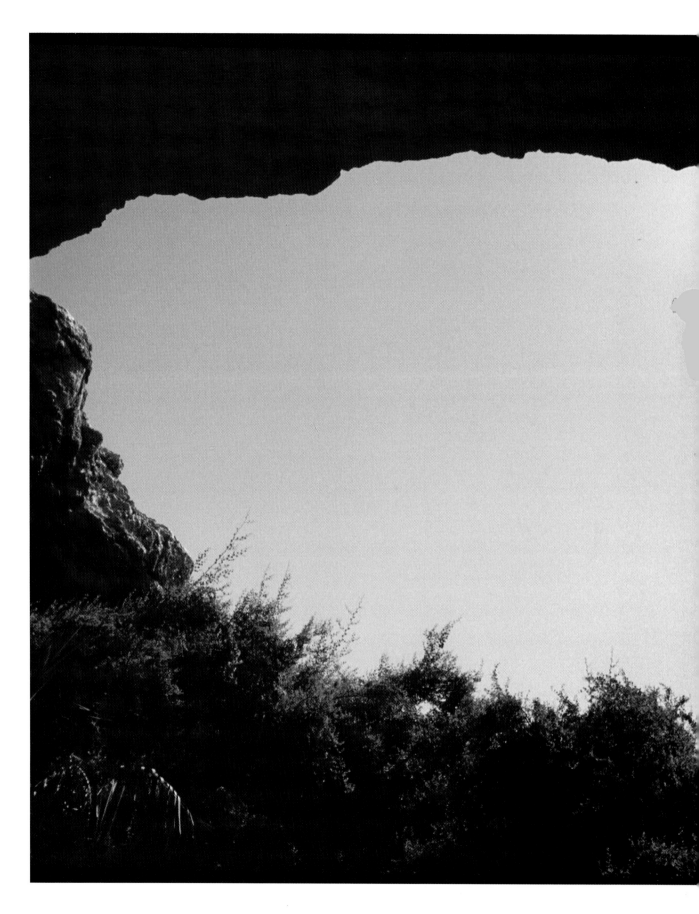

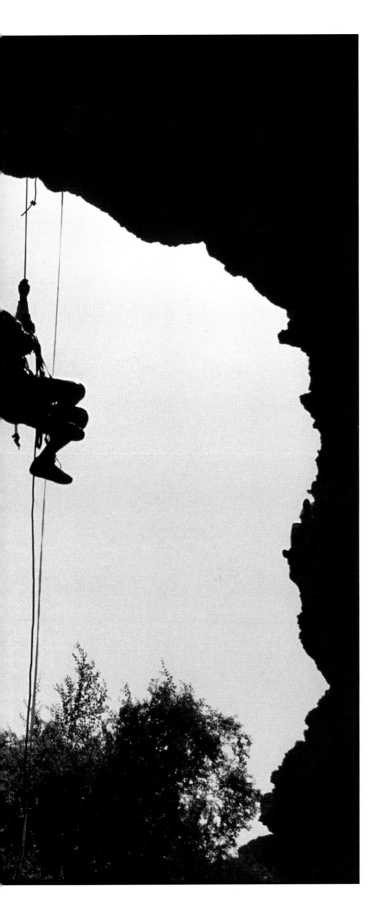

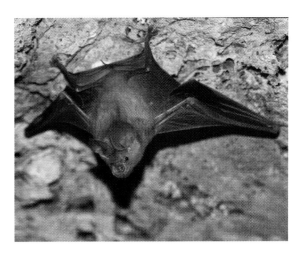

Left: Aramco geologist Greg Gregory clearing the tree tops in Dahl Abu Jirfan.

Above: trident bats (Aselia tridens) live in several of the caves and eat harmful insects like sand flies. The bats can range as far as 50 kilometres in a single night.

يسار: الجيولوجي "جريج جريجوري" من أرامكو يقوم بقطع رؤوس الاشجار في دحل أبو جرفان.

أعلى: تعيش الخفافيش في عدة كهوف وتتغذى على الحشرات المؤذية مثل الذباب الرملي ويمكن ان يتجول الخفاش لمسافة ٥٠ كيلومتراً في الليلة الواحدة.

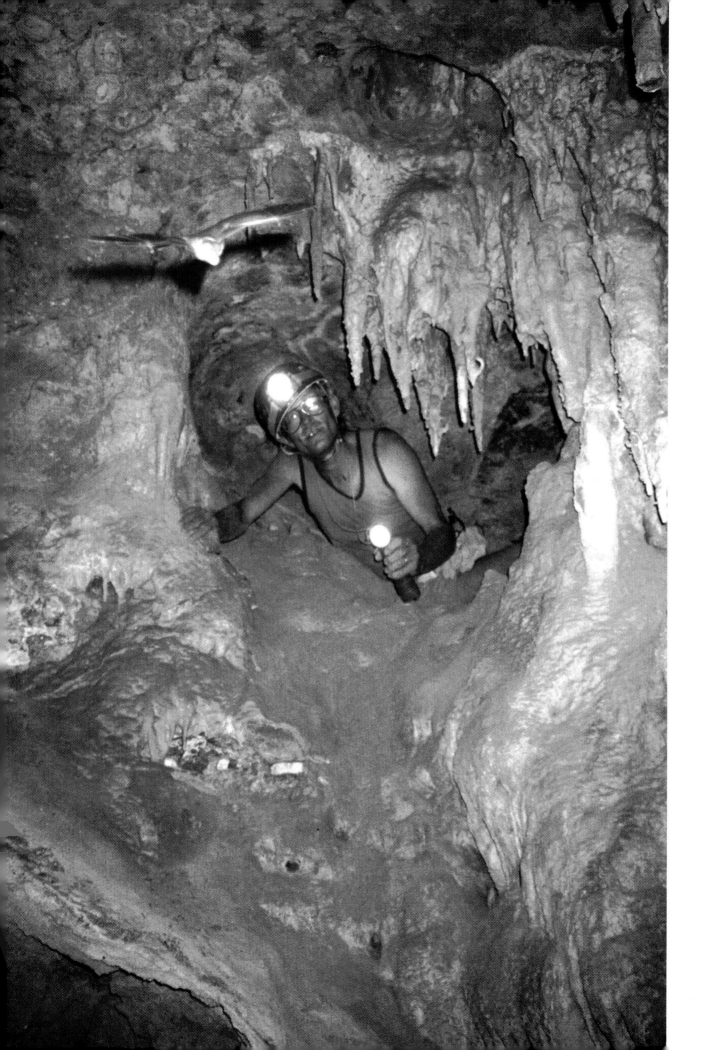

Left: the bats in Thousand Wings Cave live in two small alcoves off the main room of the cave.

Right: people from the town of Shawiyah (seen here inside Iftah Cave) have guided explorers to hard-to-find caves in the Summan karst.

Below: Dahl Kfaitan is located in the northwest of Saudi Arabia, where the cave exploration is just beginning.

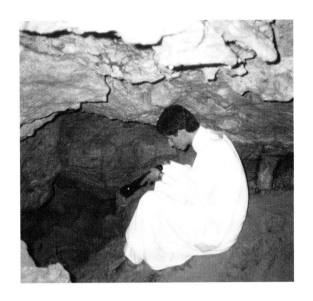

يسار: تعيش الخفافيش في كهف "الألف جناح" داخل فجوتين صغيرتين خارج الحجرة الرئيسية للكهف.

يمين: أحد أهالي الشاوية داخل كهف "إفتح" والذين قادوا عدة مستكشفين الى كهوف مجهولة في هضبة الصمان.

أسفل: تقع هذه الحفرة في المنطقة الشمالية الغربية من المملكة العربية السعودية حيث بدأت أعمال استكشاف الكهوف.

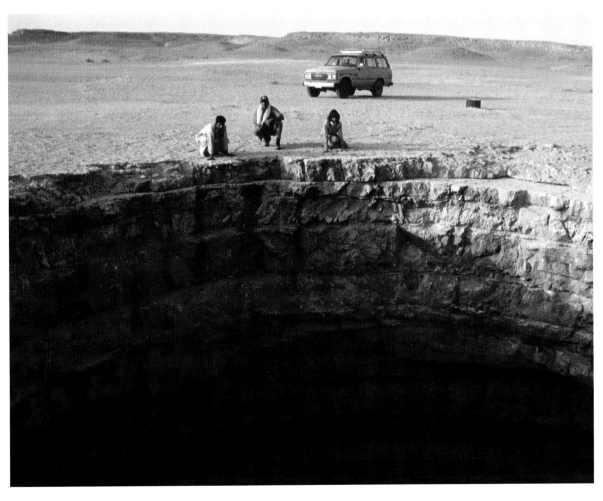

Below: what does it look like underneath this big, flat desert? As ever, a picture is worth a thousand words.

Right: deep grooves in the walls of Dahl Hashami attest to its many years of service as a water well.

أسفل: ماذا يمكن أن يكمن تحت هذه الصحراء الكبيرة المنبسطة؟ وكما هو الحال فإن صورة تساوي الف كلمة.

يمين: تشهد الاخاديد العميقة على جدار "دحل هاشمي" على أنه كان يستخدم كبئر ماء لعدة سنوات.

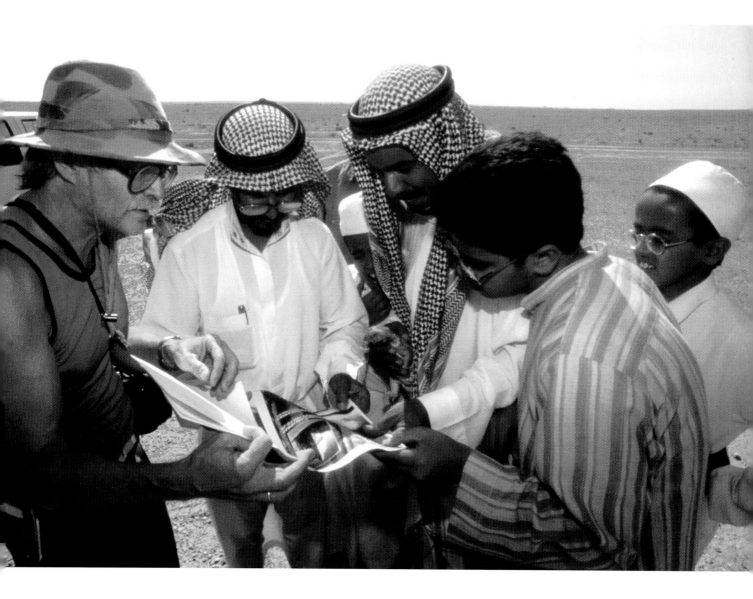

Overleaf: sunset on the Summan Plateau. A weary caver ends a full day of exploration with a prayer.

على ظهر الغلاف: الغروب على هضبة الصمان حيث ينهي أحد المستكشفين يوماً مضنياً من أعمال الإستكشاف بأداء الصلاة

118

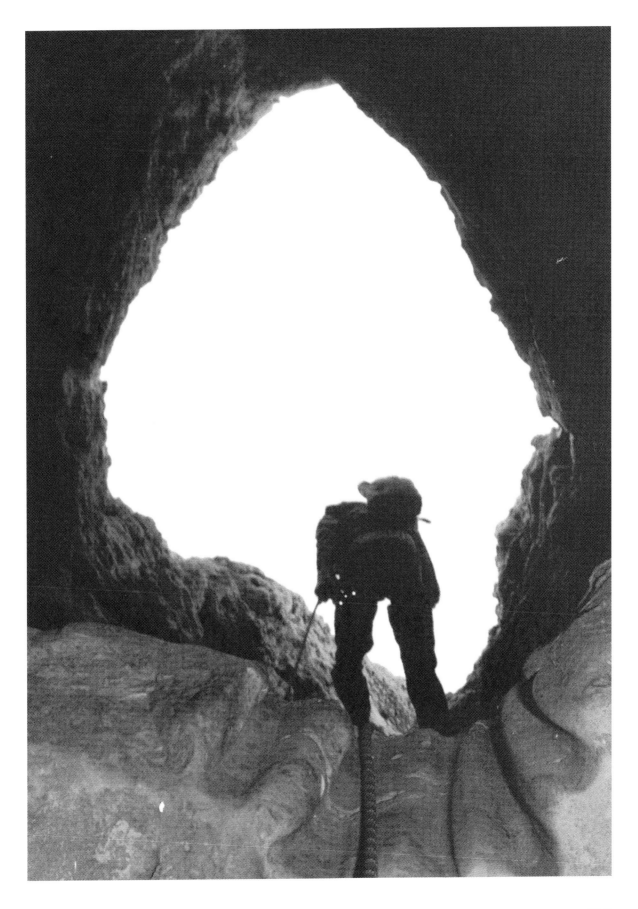

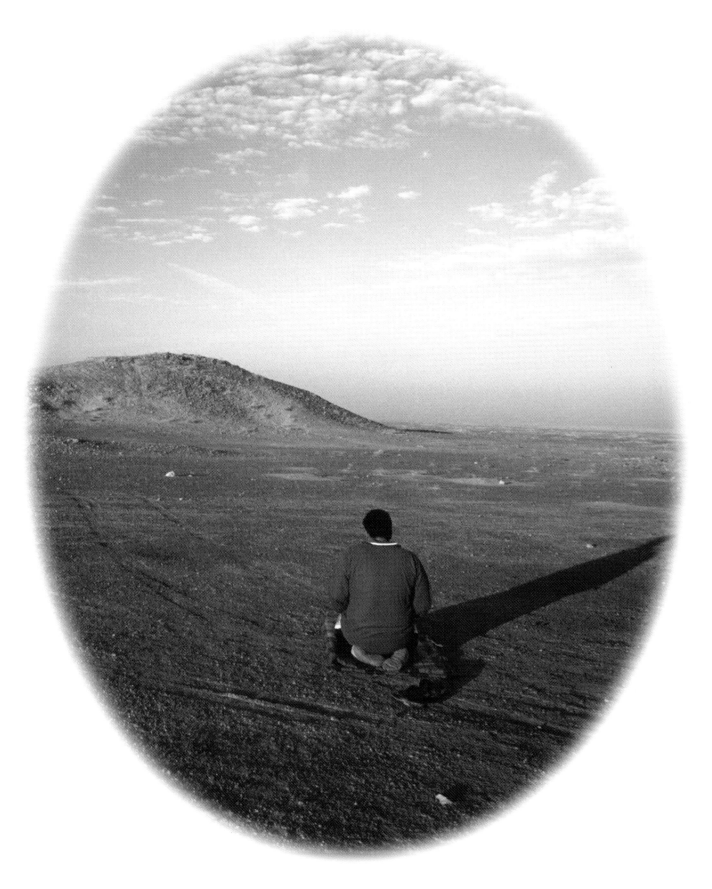